PAINTING WILDLIFE
in WATERCOLOR

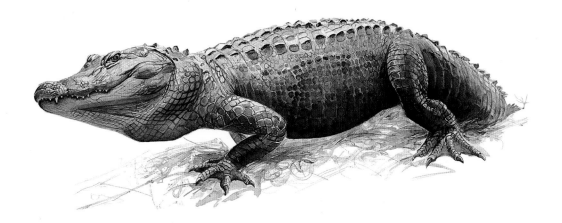

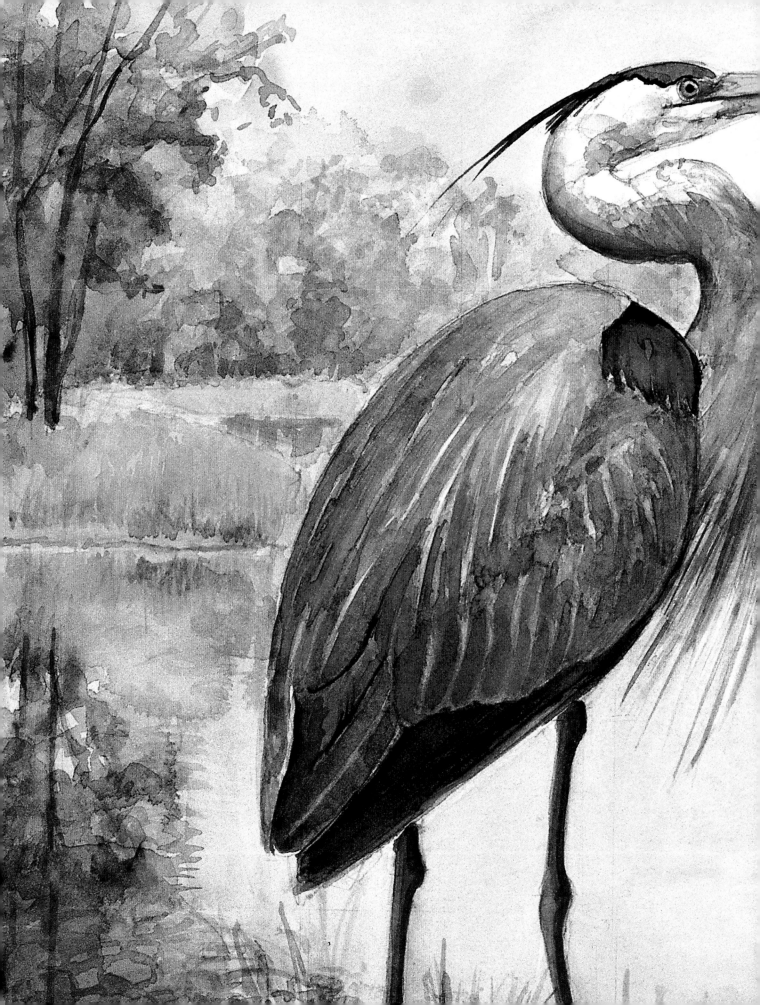

PAINTING WILDLIFE
in WATERCOLOR

PEGGY MACNAMARA
MARLENE HILL DONNELLY

WATSON-GUPTILL PUBLICATIONS/NEW YORK

This book is dedicated to the Field Museum community, who created the world in which our work was born.

Senior Acquisitions Editor: Candace Raney
Editor: Michelle Bredeson
Designer: Patricia Fabricant
Production Manager: Hector Campbell

All artwork by Peggy Macnamara. All artwork collection of Peggy Macnamara, unless otherwise noted.

All photography by Paul Lane, except photo of Peggy on page 13 by Dorothea Tobin; photo of Peggy on page 18 by Paul Brunsvold; photo on page 20 by Peggy Macnamara; photo of cheetah on page 88 by Marlene Hill Donnelly; zebra demonstration on pages 92–96, and parrot demonstration on pages 114–115 by Diane White.

Published in 2003 by Watson-Guptill Publications, a division of VNU Business Media, Inc., 770 Broadway, New York, NY 10003
www.watsonguptill.com

Library of Congress Cataloging-in-Publication Data

Macnamara, Peggy.
 Painting wildlife in watercolor / Peggy Macnamara and Marlene Hill Donnelly.
 p. cm.
Includes index.
 ISBN 0-8230-3869-6
 1. Wildlife art—Technique. 2. Watercolor painting—Technique. I. Donnelly, Marlene Hill. II. Title.
 N7660.M27 2003
 751.42'2432—dc21

2003010891

Manufactured in Hong Kong

1 2 3 4 5 6 7 8 9 / 09 08 07 06 05 04 03

ACKNOWLEDGMENTS

I wish to thank the staff of the Field Museum in Chicago for twenty-five years of assistance in making the drawings and paintings in this book, especially John McCarter for generous support and encouragement, and the Zoology Department for welcoming me into the collections: Dave Willard, Tom Gnoske, Phil Parrillo, Dan Summers, Jim Louderman, Margaret Thayer, Petra Sierwald, Mary Anne Rogers, Kevin Swagel, Bill Stanley, Robin Foster, Tatzyana Wachter, and Steve Goodman. They included me on expeditions, critiqued work, answered questions, and provided photos. Paul Brunsvold encouraged me to paint things I never would have considered. Debby Moskovitz saw what I could contribute to the museum before I did and helped give direction to my efforts. Thanks to my husband, Jack, and my children, Meghan, Coleen, John, Katie, Bill, Dan, and Pat, for their patient readings, objective critiques, and endurance during this endeavor.

I also wish to thank my early readers Caitlin Creevy, Anne McGivern, Father Dan Flaherty, Nancy Zannini, Caleb Mason, Ellen Galland, and Jack and Margaret O'Connor, as well as my colleagues at the Art Institute of Chicago who have contributed their expertise: Susan Kraut, Elizabeth Ockwell, Olivia Petrides, and Tim Anderson. Special thanks to my tireless photographer Paul Lane. There would be no book without Marlene Hill Donnelly's superior writing ability and technical knowledge.

PEGGY MACNAMARA

I thank Jude Mandell for her invaluable expert critique services and editorial advice, and my other outstanding critique group colleagues, Sara Shacter, Bev Patt, Mary Ann Bumbera, Ruth Spiro, Bev Spooner, and Sarah Roggio, for excellent advice and endless patience. I am grateful to John Dioszegi for generously sharing his prodigious knowledge of the technique and philosophy of watercolor. I thank my husband, Rett, for all of his support and sound advice throughout. Finally, I thank Peggy Macnamara for allowing me to share in this wonderful and enriching project, from which I have learned a great deal.

MARLENE HILL DONNELLY

CONTENTS

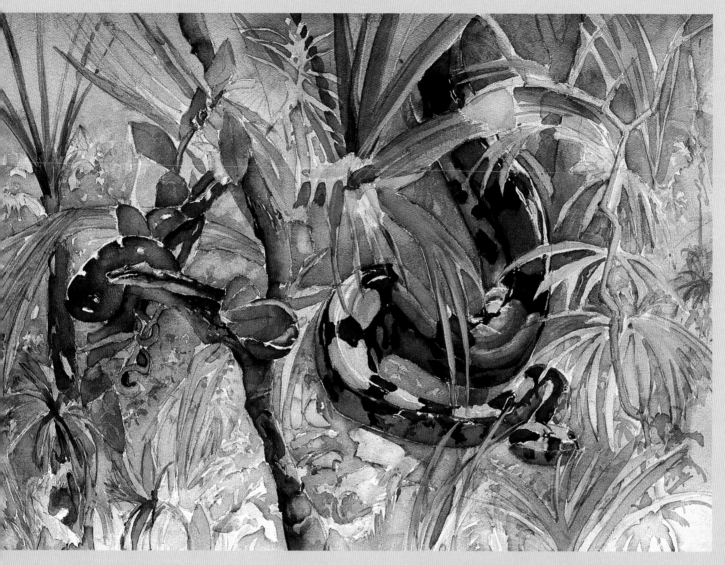

BOA CONSTRICTOR IN HABITAT
30 x 40 inches (76 x 102 cm)

PREFACE

My painting process is a form of active meditation—I concentrate so completely on my painting that everything else seems to slip away. Afterwards my life isn't screaming so loudly, and I feel quiet. I feel extraordinarily fortunate every day when I sit down to paint, and I hope to pass this feeling on to you by teaching you my "no-fear" process.

This process is one of many light layers. Applying many layers means making lots of small decisions, and therefore avoiding the huge, lethal mistakes that plague other watercolor processes. Layering color builds glowing intensity and creates luminous neutrals. Since color choice within my process remains very personal, your paintings will reflect your own vision.

Often the seed of talent is just a leaning or strong curiosity. It doesn't matter how old you are, what technical expertise you possess, or how good you'll be. I began with mediocre drawing skills, no color sense, and hardly a clue as what to paint. But I loved the process and that was enough.

I began my career painting the human figure. My work evolved to wildlife painting because I was fascinated by the endless diversity of beauty and expression that exists in the natural world. Not only are animals exquisite in their own right, they often reflect humanity from a different perspective. Just as a science fiction writer uses strange settings and circumstances to induce a new perspective on life, the wildlife artist paints the familiar yet alien expressions of animals with a truth that crosses the barriers of species. My many-layered method is natural for wildlife subjects. It automatically builds depth in the liquid expression of the eyes as well as in the rich texture of fur and feathers.

So if you feel any inclination, hear any little nudging voice, or just want to draw and paint, *then follow that lead.* Beginning doesn't require an invitation. Just put something down on paper. As soon as you can see a mark, you'll form an opinion about it and start the ball rolling. You'll sometimes love it, occasionally hate it, want to adjust, change, and rework it, until you find yourself practicing art. It's supposed to be hard and frustrating, joyous and satisfying. That's the deal. Creating art is no different from raising kids, staying in a relationship or leaving one, getting old, or falling in love. Art has success, failure, surprise, and adventure. The trick is not to quit.

So if you love drawing and watercolor, or are just curious, then join me now.

PEGGY MACNAMARA

What to Paint and Where

Paint what you love. That sounds obvious, but we often paint what everybody else paints, or what we think will sell. Your true feelings for your subject will shine through your finished painting.

Wildlife painting is particularly challenging as well as rewarding. Because wild animals are often difficult to locate and study, I use more than one resource for my work. In this chapter I'll guide you through the advantages and drawbacks of working in the field, in zoos, at natural history museums, and from photographs. In the end I hope you'll combine resources to fit your own personal style.

SANIBEL ISLAND I
22 x 30 inches (56 x 76 cm).
There is so much more to field sketching than merely drawing a subject. Here I've tried to capture the feeling of timeless harmony that exists between the land and the animals that have made their home on this island off the Florida coast for thousands of years.

DRAWING AND PAINTING FROM LIFE

It's easy for an artist to become so focused on the end product that the process is lost. But you're not producing a photographic image—you want your presence and excitement to be felt by the viewer, and for that to happen there needs to be evidence of the process on the page. Struggling to work from life brings the live animal and my experience of it to the paper. I feel as if I'm talking to the viewer while painting, saying, "Look at this unusual gesture or shape, and see how the light hits the feathers around his neck and how the shadow looks almost green!"

Work from life whenever possible. Painting or sketching from a live subject creates immediacy, a bond that's missing when working from a photograph. Art can be so intimidating that it's tempting to do only what we're good at. Working from life is a great way to practice taking risks while collecting valuable impressions.

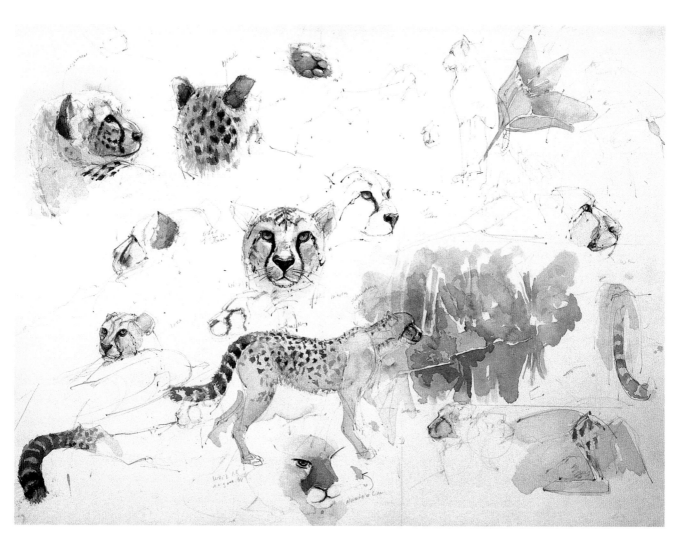

CHEETAHS
22 x 30 inches (56 x 76 cm).
I painted these cheetahs at Lincoln Park Zoo in Chicago.
These graceful, restless cats are seldom still. The key for me was
patience; I gave myself plenty of time, and they did indeed return
to the same pose, if only for a few seconds.

WORKING IN THE FIELD

Field sketching in wild habitat offers the truest possible connection with wildlife. Animals in the wild are on their own turf—I am the guest. Remembering that I'm uninvited, I sit and observe with patience and humility.

Begin working in the field by adjusting your attitude: This is not about drawing an image. It is about getting in step with your subject—you'll observe behavior, capture gesture and color, and absorb habitat. You are gathering information, coming to know and understand other beings.

Working in the natural environment invokes a whole new perspective and appreciation for your subject. An animal that seems sluggish and indolent at the zoo is probably just bored—in the wild he is alert and competent, his senses and skills honed to perfection by millions of years of evolution. Even if you catch only a glimpse of him in the wild, you'll walk away with a greater respect and understanding that will later appear in your painting.

Take notes as you work. The notes you scribble on your sketches add a lot to their value, both for future finished work and for remembering the moment. A wonderful bit of quirky behavior or flash of haloing light often passes too quickly to illustrate fully, but a few written words along with your abbreviated drawing will hold that moment for you forever. Include notes about surrounding sounds, scents, and tactile sensations. Even if they don't seem relevant to the subject, reading these notes rallies all your senses—even years later—to bring back the scene.

I can count on two things when drawing live animals (assuming they don't just disappear!). First, they move around *a lot*. Second, they return to the same poses again and again—remembering this preserves my sanity.

When the animal is moving around I watch and wait, hoping he'll settle into a still pose. In the meantime, without looking at my paper, I make light "movement lines," beginning with the animal's head, down his spine to the tip of his tail.

If the animal I am sketching refuses to pause, I lower my expectations another notch and switch to Plan B. Each time he ambles by, I consciously observe and add one feature. Perhaps all I can glean in one pass is that his eye is one-third of the way between the forehead and the back of the skull. Or perhaps I will note how light glances off his shoulder blade as his weight shifts. It's like a puzzle—you get what you can, and fill in missing pieces over time.

While this sounds tedious, it's actually a valuable exercise—the stuff of visual memory. Information mined like this, one precious nugget at a time, has a way of sticking in my head better than that gathered from a still subject and traditional drawing methods. When I'm ready to create a finished painting, I'll have a whole mental library of images and impressions to draw from, in addition to my sketches.

The first half hour of a sketching session is warm-up—it takes that long to get into the rhythm of the task. Sit, study your subject, and lower your expectations. At first it will feel like being stuck in traffic—you move for a while, stop dead, and move again, with little control over your pace. You need to surrender to this lack of control and realize that you were slowed down for a reason.

I use inexpensive paper for my warm-up drawing, moving on to watercolor paper when I feel ready. At this time I lay out a simple but complete palette (see Chapter 5, "Watercolor Basics."). I sketch four or five typical poses as well as a few close-ups of the head and feet. I then add my first washes (see Chapter 6, "Peggy's No-Fear Painting Process"), rotating among the drawings to allow drying time. I'm forced to work from larger shapes down to smaller ones because I only get an occasional glimpse from any given angle. When the pose reappears I can add bits of detail.

This was the last nice day of fall at Lee Street Beach in Evanston, Illinois. I painted rocks and fall color on the trees. Shorebirds wandered into my line of vision; I sketched their gestures and how the bright sun reflected the color of the sand onto their bellies. While wind and blowing sand are a challenge, they're a good reminder of the elements that shape my subjects' lives. To impart a feeling of presence in my finished paintings, I'll keep this in the back of my mind as I work in a more hospitable environment.

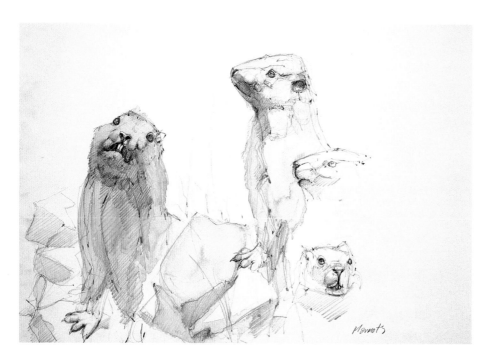

HOARY MARMOTS I

8 x 10 inches (20 x 25 cm)

As I stumble across an avalanche track in the High Cascades of Washington state, marmots appear like sprites and bubble among the boulders with liquid grace.

HOARY MARMOTS II

15 x 17 inches (38 x 43 cm)

The marmots vanish, and I sit and sketch rocks. But invisible strings of curiosity pull these young animals into the open again. I move only my eyes and fingers, and the marmots begin to relax. A half-grown pair wrestles and rolls on a narrow ledge, finally sitting up and slumping back-to-back, bookend style.

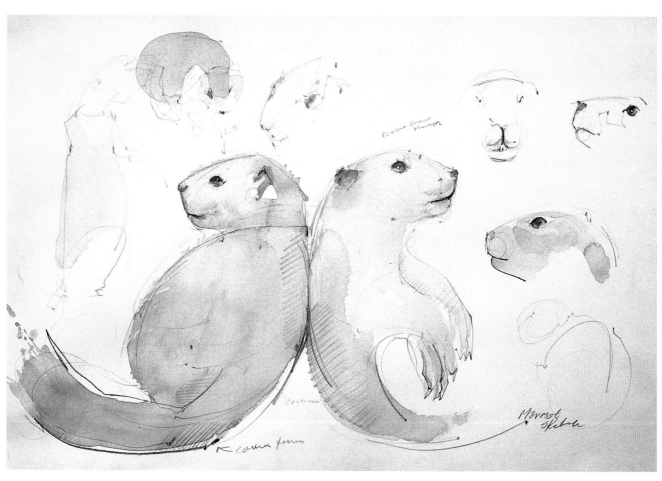

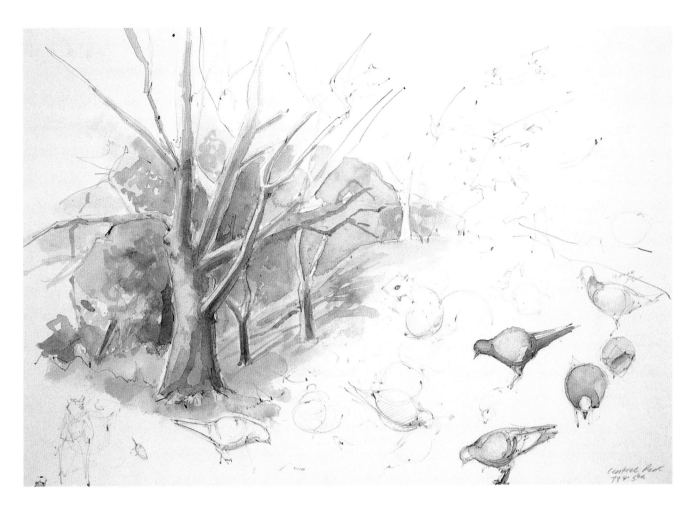

CENTRAL PARK

10 x 14 inches (25 x 36 cm).
Collection of Katrina and Wesley Mason.
Notice the "movement lines" of pigeons and squirrels I didn't have time to complete. Sketch in familiar as well as exotic locales. You'll see something new every time and strongly deepen your sense of place.

SANIBEL ISLAND II

22 x 30 inches (56 x 76 cm)
To sketch the flying egret I had to watch him make many passes—with each pass I noticed and sketched a new feature.

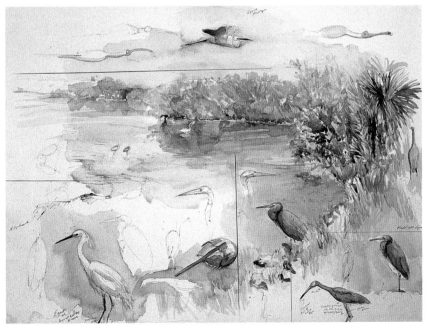

Sketching at the Zoo

While working in the field is ideal, natural habitats are often too far away, too cold, too wet, or too dark for practical purposes. At this point the zoo becomes a great resource.

To begin, find an animal subject that appeals to you but isn't moving around too much. For example, the big cats are great to sketch when sleeping, but are a considerable challenge to paint when they're pacing and leaping. Save them for later! Camels, on the other hand, generally move slowly, but are a great subject filled with character and attitude.

I usually sketch in one place for at least half a day, and in that time the animals' keepers often approach me. These knowledgeable people care deeply about their charges and have a wealth of information. In general, zoo personnel are very friendly and welcoming to artists.

The procedure for working at the zoo is the same as in the field; the main difference is that you're in a very public place. An artist often attracts a crowd, mostly friendly and complimentary, and I usually enjoy talking to people. If I need to work undistracted, however, a preoccupied smile and nod is usually enough to deflect unwanted questions. For serious privacy, wear a headset.

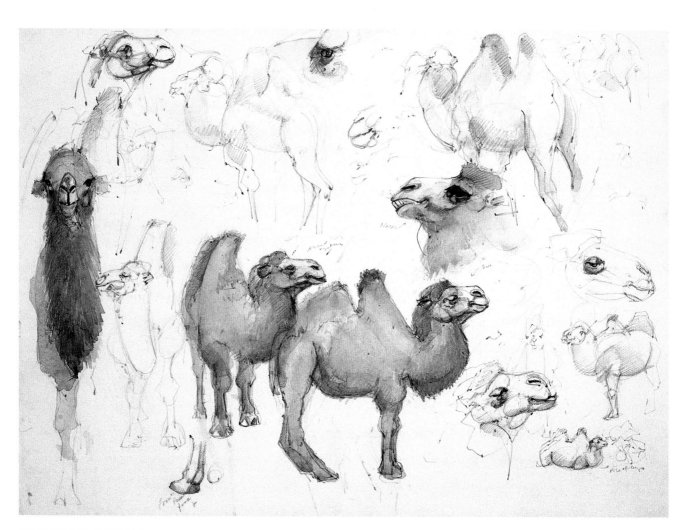

BACTRIAN CAMELS
22 x 30 inches (56 x 76 cm)
Camels aren't the placid beasts of burden you see in the movies. Though often affectionate and companionable, when riled they spit stomach acid, and lots of it! A male camel's long prehensile lips hide 2-inch (5-cm) canine teeth and jaws that can open wide enough to engulf a person's whole head. There are advantages to working behind a barrier!

AFRICAN ELEPHANTS

22 x 30 inches (56 x 76 cm)
These elephants were a wonderful study in neutral colors. The way the colors shifted as the natural light changed was amazing.

CHILEAN FLAMINGOS

22 x 30 inches (56 x 76 cm)
The birds were in a fairly small domed enclosure, and I was close to them. They were great to work with because they all assumed similar poses at different times. This meant that when one subject moved, I could often continue on the same sketch by looking at a neighboring bird that had just taken the same pose.

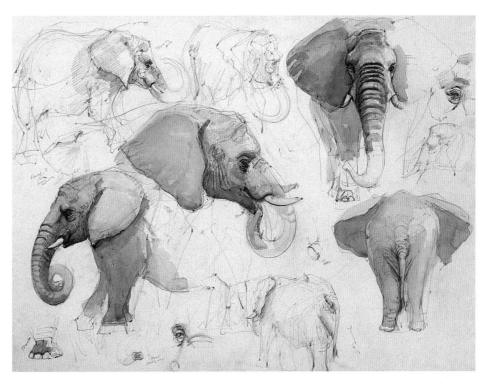

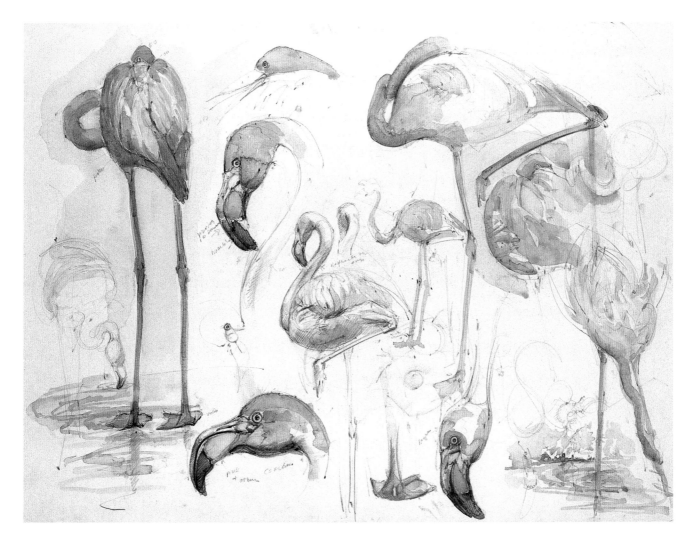

WORKING IN NATURAL HISTORY MUSEUMS

As an art student I was a slow learner. In figure class, the model inevitably moved. I never had time to get the pose right, and I had no confidence in my abilities. Drawing at Chicago's Field Museum has allowed me time to fumble through the learning process, make lots of mistakes, and work at my own pace in a calm state. Every day I can visit the animal or bird I'm working on and find it waiting for me to try again.

There is a meditative aspect to simply having time. After an hour or so I find I have shaken loose of everyday concerns—I've entered the "art zone." This in itself is of value, whether or not the finished piece works. I look slowly, spending two or three minutes in the same spot, to truly see a shadow's color or a delicate pattern. From within this state I can make intuitive decisions that don't come easily at other times.

You're in a different sort of art zone working from life, where you have to put together bits and pieces and watch them fit together and emerge as a whole. At a museum you can dig into an image, giving solidity to form and developing maximum detail. Mounted specimens allow the immediacy of a real subject and the luxury of a still one—with unlimited working time.

What you give up in working from a mounted subject is the sense of movement—that's why it's so important to draw and paint from life as well. The mental archive of gesture and expression you build working in the field and at the zoo floats in the back of your consciousness, breathing life into your time-enhanced process at the museum.

While most natural history museums are as welcoming to artists as are zoos, it never hurts to check ahead of time, especially if you intend to set up an easel. Special exhibits are occasionally off-limits to both artists and photographers.

I step into the Field Museum's Animal Kingdom exhibit on a cold January day and can't believe my good fortune. It is very still, warm, and peaceful. I sit down in front of a bird or mammal and feel no urgency. I have forever to get it right. Time is your friend at a natural history museum.

WOLVERINE

30 x 22 inches (76 x 56 cm). Private collection.
Largest of the weasels found in the forests of North America, the wolverine is a notoriously fierce and independent creature. This fresh, quick sketch done at the Field Museum takes its strength from gesture, line, and color. Working at the museum gave me the time to really see detail and develop the features.

SUE (FIELD MUSEUM, CHICAGO)

22 x 30 inches (56 x 76 cm). Collection of Marlene Hill Donnelly.
"Sue" is the world's largest and most complete Tyrannosaurus rex skeleton. Bones are essentially beautiful sculptures and can make striking subjects. Drawing and painting skeletons teaches animal structure and will help make all of your other work convincing. A natural history museum, like the Field Museum, offers a wonderful range of subjects.

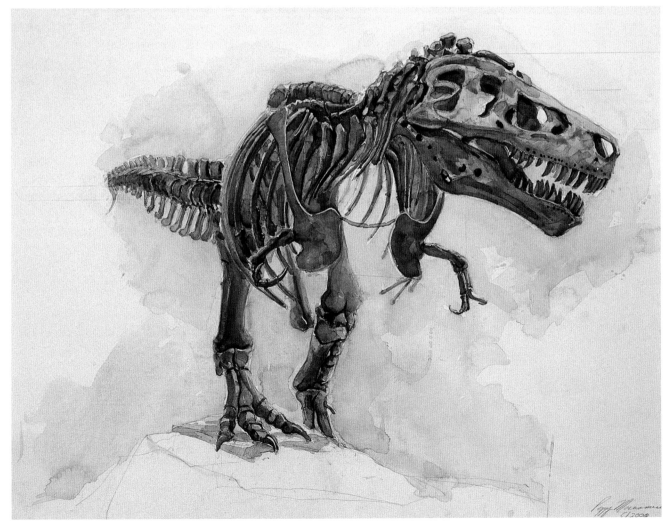

USING PHOTOGRAPHS AS REFERENCES

When photography entered the scene in the middle of the nineteenth century, it changed how artists saw and rendered reality. It recorded subjects in a way that was previously the job of the painter, freeing the artist to represent the surrounding world in many unexplored ways. Degas' avid photography influenced his compositions—he began cropping painted images in a way that hadn't been done before. Photo-realists took this tool to a new extreme, making the photograph a collaborator.

Personally I feel that working from a real subject, live or mounted, is infinitely more interesting and rewarding than working from photographs. However, I also believe that art is difficult enough and that we should use all the tools we have available. Few professional artists today work entirely camera-free. You never have complete control over a painting, but at those times when you feel as though you're not working with the piece but chasing it, supplemental photographs can help a lot.

That said, I would certainly discourage you from working entirely from photos. You lose too much life, too much presence that way. While the camera is a useful and often necessary tool, I find that it creates a barrier, both literal and figurative, between my subject and me. Besides, copying slavishly from photos is simply no fun—the process suffers. Instead, use photos as references to create backgrounds or for painting details you were unable to see in your live (or mounted) subject.

For example, perhaps you got a good start in the field, but just couldn't see your deer's feet well enough. You can't paint at the zoo because it's pouring rain; the museum's deer is in the wrong position, and your painting has to be finished for a show in two weeks. It's time to pull out the camera, take a couple of quick shots at the zoo, and complete your work in the studio.

I use 35-mm film; at the high resolution required to see accurate detail, my digital camera runs through batteries too quickly to be practical in the field. Telephoto lenses, from 200 mm to 1000 mm, are often a necessity to capture natural behavior at a distance (as opposed to photographing retreating rear ends up close!).

When hiking long distances with a heavy pack, I sometimes carry just my pocket-sized digital Canon Elph. It takes remarkably good habitat images, in both standard and panoramic formats.

I took this photo while floating down a river in Madagascar in a native boat. I had barely enough time to snap shots of the lush riverbanks as we glided by. Later I used the photos to paint a great background for the radiated tortoise I had sketched earlier.

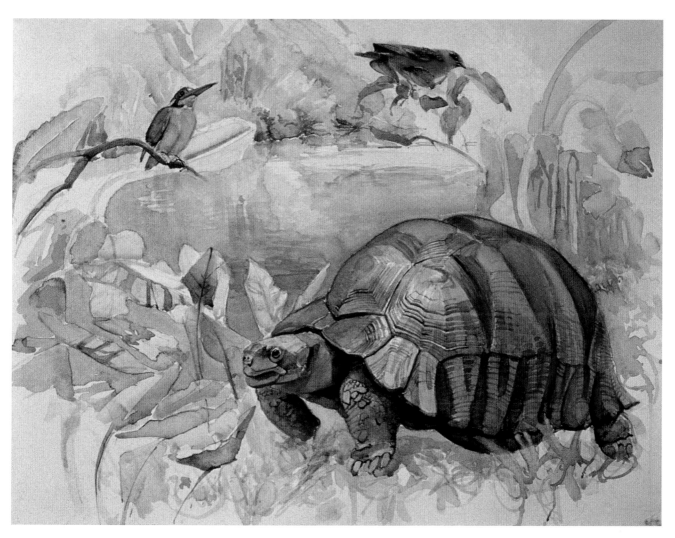

RADIATED TORTOISE
22 x 30 inches (56 x 76 cm).
Collection of Michi and Thomas Schulenberg.
Without the help of my camera, I wouldn't have been able to paint the background for this turtle. But photos almost never catch the unique and subtle lighting that makes a live plant so exquisite— even with background photos I try to obtain live plants of similar species to work from.

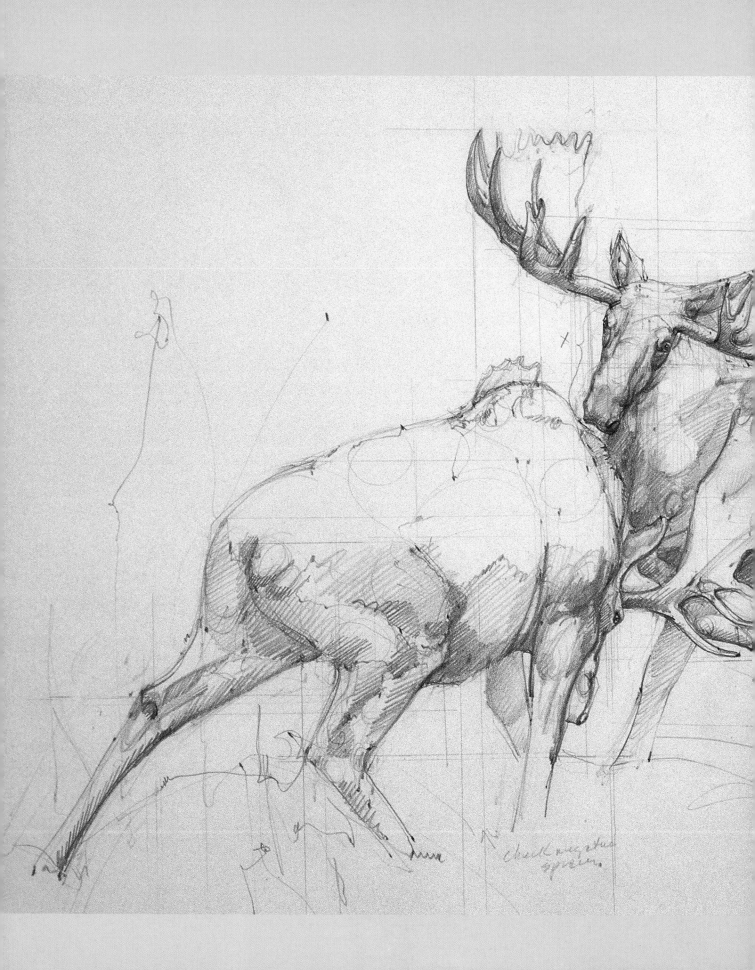

Drawing

A drawing provides the bones of a painting. Solid and accurate, or weak and distorted, your drawing is the foundation of your finished piece. You'll discover amazing beauty in unexpected places on your path to a strong drawing. Drawing is an active form of meditation that will extend into all other aspects of your life—you'll begin seeing in an entirely new way. Once you connect with the flickering glint in the depth of an eye or the cool, luminous shadows in thick fur, you can't help but look for these marvels everywhere around you. The world gradually becomes a more beautiful and interesting place.

MOOSE DIORAMA (AMERICAN MUSEUM OF NATURAL HISTORY, NEW YORK)
22 x 30 inches (56 x 76 cm)
Only at a natural history museum can you capture this kind of action combined with great detail.

GETTING IT RIGHT

To create a strong painting, you have to start with a strong drawing. There is no escaping this reality. The good news is that you can take all the time you need to "get it right." No painting's label in an art museum has ever included the words "Amount of Time Taken."

Work large, life-size if possible. The bigger the drawing, the smaller the mistake. If you're off by 1/16 inch in a 20- by 30-inch drawing, it's probably not a big deal. The same fraction of an inch in a 2-inch piece constitutes a large percentage of the whole.

It's best to begin with large shapes and work your way down to the smaller ones. If you begin with detail and fall in love with it, you'll be very reluctant to make changes, no matter how necessary. Squint for shapes and values (shades of light and dark). Forget for the moment that you're drawing a dinosaur or a frog.

First make it strong. Then make it pretty. Your work is about the whole, not a study of parts. Move your pencil around the drawing. Don't stay in one place for too long; loitering destroys balance.

Assume your initial efforts are off, as they're supposed to be. Most time spent drawing consists of editing, especially at the beginning. Be patient. I've found that those who have had to fight hardest while they're learning achieve the most success in the end. Your abilities develop only if you do the work.

Be mechanical in the beginning: Measure. Yes, the M word. It will save you time in the long run. All professional artists measure in some way. I've been drawing since I was a small child (and that's a long while) and I still have to measure for every drawing. But the more you do it, the faster you'll get, so the trick is to start now.

Observe the pace of spiders spinning webs or birds building nests. These creatures work methodically, with no regard for time—a steady progression of small tasks. The same approach will serve you well as you draw.

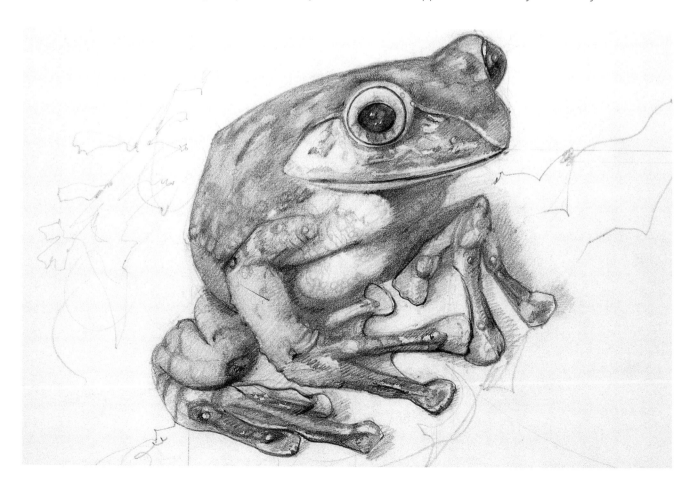

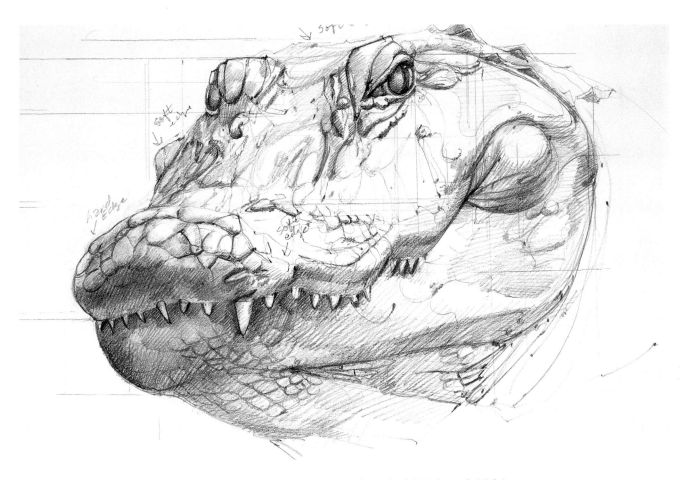

DRAWING MATERIALS

There are a variety of drawing pencils available, ranging from very hard and light to very soft and dark. I like to use B pencils, because they are dark, but still easy to erase. I begin sketching with drawing paper (I like Strathmore), but eventually move to watercolor paper (see "Paper" on page 62). Some type of drawing board is required even if you use a pad of paper. You can buy a commercial drawing board or just use your folio case. I like to use a piece of Gatorboard, a light, sturdy foam board. You'll also need a pencil sharpener. Some of my students like the small portable electric sharpeners, but a manual one is fine. A few other indispensable items include tape or clips (to secure paper to board), a kneaded eraser, a triangle, and a T square.

TREE FROG
8 x 10 inches (20 x 25 cm)
All sorts of subjects make wonderful drawings—don't think in terms of just lions and tigers and bears.

AMERICAN ALLIGATOR
10 x 15 inches (25 x 38 cm)
Alligators are wonderful subjects for the study of both expression and detail. While I've often sketched them live in the wild, it's a great luxury to be able to study their beautiful scale patterns at leisure at the Field Museum.

You need only a few basic materials to get started drawing.

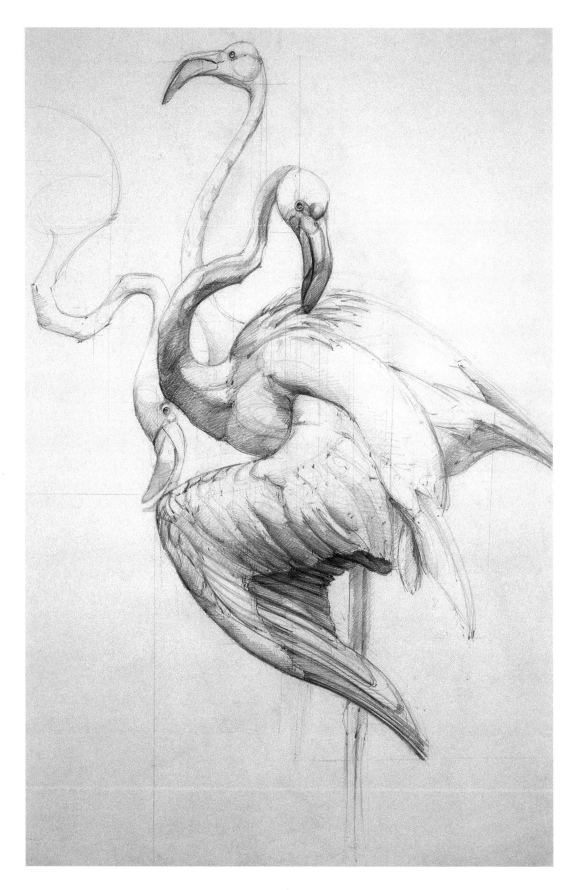

THE DRAWING PROCESS

The drawing process can be broken down into six basic steps: slow looking, a gesture sketch, finding the home length and comparison measuring, creating stepping stones, establishing values, and defining edges.

SLOW LOOKING

Take a few minutes to really look at your animal subject. What is he doing? Is he languidly sprawling or tensely alert? What do you particularly like about the subject? Where is the center of interest? Spend as much time as you need to get a really good sense of your subject.

THE GESTURE SKETCH

The gesture sketch consists of a few loose, expressive lines that indicate the basic posture of your subject, and establish its size and position on the paper. You'll touch on each of the major elements: head, limbs, and joints. This takes only a minute or two. Gesturing loosens your hand and establishes position. It is not meant to be accurate. Gesture gets something on the paper so that you'll be able to proceed with measuring.

FINDING THE HOME LENGTH AND COMPARISON MEASURING

The more you measure, the more accurate your drawing will be. That's the deal. You will measure for both size and location. The good news is that measuring has very little to do with math. Rather, it has everything to do with visual relationships.

To measure your subject, hold your pencil at arm's length in front of it. Keeping your arm fully extended at all times, close one eye. Measure the head from top to bottom with your pencil, using your thumb to mark the spot on the pencil.

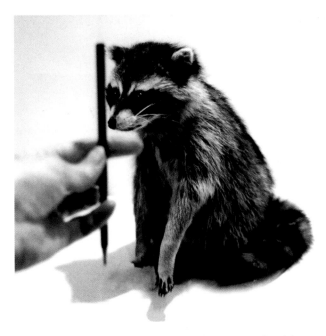

I use a pencil to measure the height of the raccoon's head from top to bottom, marking the spot with my thumb. I will use this rough measurement to compare and measure all other parts of the raccoon.

The "home length" is the length of a standard, easily measured feature of your subject that you use to compare with every other feature that you wish to measure. The home length is usually the head if you're drawing the whole animal. To begin with, count how many home lengths fit into the height and width of your subject.

With a T square and triangle, draw plumb lines (straight vertical lines) and make a grid that will show you the relationships you need to establish. You'll drop these lines at key features, such as the front of the nose, the top of the back, or the bottom of the belly.

Diagonal lines are determined by comparison with vertical and horizontal lines. In other words, when you put a box around an area, it becomes much easier to judge an angle within the box. Where is the nostril in relation to the eye? How far down is the nostril from the eye? Once you determine these points, you can draw the angle of the head.

You've done your groundwork and positioned all of the major elements. Now you'll be working from the inside out, breaking larger shapes into small shapes.

CHILEAN FLAMINGOS
40 x 30 inches (102 x 76 cm)
The graceful lines of a flamingo contain infinite possibilities for expressive design.

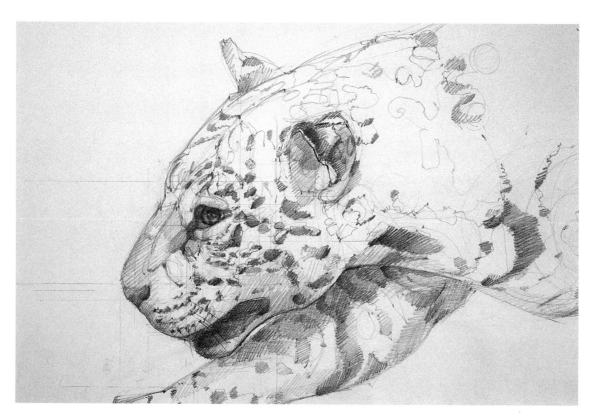

JAGUAR

22 x 30 inches (56 x 76 cm). Collection of Thomas Moroney.

I've tried to capture the strength and stealth of this solitary big cat. After establishing the planes of the head I concentrate on developing the features and patterns, such as the jaguar's distinctive spots.

CREATING STEPPING STONES

Since you already have the size and location of the major features indicated through measuring and plumb lines, you can relax while concentrating on the small shapes within the larger shapes. This doesn't mean that you won't continually measure and correct, but you can be confident that any changes will be relatively minor.

There are three kinds of shapes to take into account when drawing an animal: planes, features (such as the nostril or the eye), and patterns.

Planes are areas that maintain a given angle to the light. Think of the planes of your face—the top of your nose compared to the sides, the front and sides of your chin, the slope of your forehead.

Shapes in the form of patterns can be found in all types of fur and feathers. A jaguar's spot forms a unique shape, as does the shadow behind the ruff of fur on your dog's or cat's neck. The dark bar on a pheasant's feather is a shape, as is the shadow under its wing.

Begin working with the shapes within the head. The eye becomes the "home area" of the head: It's the object you'll compare with everything else. After measuring to place the eye, begin to draw all of the shapes that surround it. You're creating "stepping stones" of shapes that lead from one feature to the next. There's great beauty in these details; most of the time we simply don't look long and closely enough to see them. Let your pencil move slowly across the paper.

Many beginning artists want to concentrate on the features, leaping from one to the next. They lose the vital in-between areas that hold everything together. Never be afraid to go back to an area—every time you do, you're likely to see some fascinating subtlety you missed the first time around.

Making a gesture sketch, measuring, and creating stepping stones work together as a system of checks and balances. If you've followed this process you should now have an accurate line drawing.

ESTABLISHING VALUES

"Value" refers to tone, the shades of light and dark that make an object appear solid and three-dimensional. Ignore values and you'll have a weak, wishy-washy image. Get them right, and your viewer will feel as though she can reach out and lift your subject from the paper. Your approach to value will be the same in watercolor as it is in pencil. Squint to see values. Squinting eliminates detail and strips a subject down to its basic values.

Shadows and light areas are deceptively simple. You must look at them for a long time to see their uniqueness. Make sure each shadow is in the correct spot. Begin by working lightly. Move from one shadow to the next without finishing any one area, keeping the whole in mind. Shade only what you see when you squint. Again, work from large to small; shadow detail will come later. Gradually define each shadow.

To appear solid an object must include light, medium, and dark tones, highlights (where the light hits the object directly), dark accents, and reflected light.

Many artists need a bit of help in judging values. For a few dollars you can purchase a commercial value finder, a small strip of cardboard printed with a gray scale in 10 percent tonal increments. To avoid ending up with pale and washed-out work, lay the value finder over your drawing or painting and squint to compare its values with those of your drawing. For good strength your work needs about 90 percent darks. You also need a 30 to 50 percent difference (3 to 5 increments on this scale) between lights and darks for sufficient contrast and to show solid form. In the end you'll probably find it necessary to strengthen contrast.

A wonderful viewing aid that neutralizes color, making values pop out, is a small piece of clear red acrylic. This tool is commercially available in quilting stores; quilters use it to see pattern as separated from color.

When you think your drawing is finished, test it for value by turning it upside down. If the form no longer looks solid, you probably need to strengthen your values. This is also a good test for accuracy of proportion.

Reflected light strikes the outer edge of a rounded object, like the head of this short-tailed albatross, on the shadow side. This is where the object turns away from the viewer. Remember: Reflected light is always darker than any other value in the light areas, such as the forehead of the albatross.

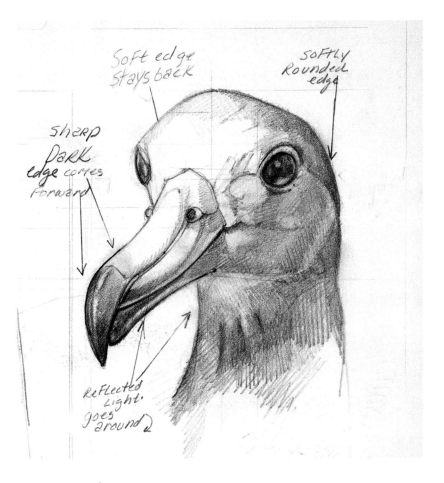

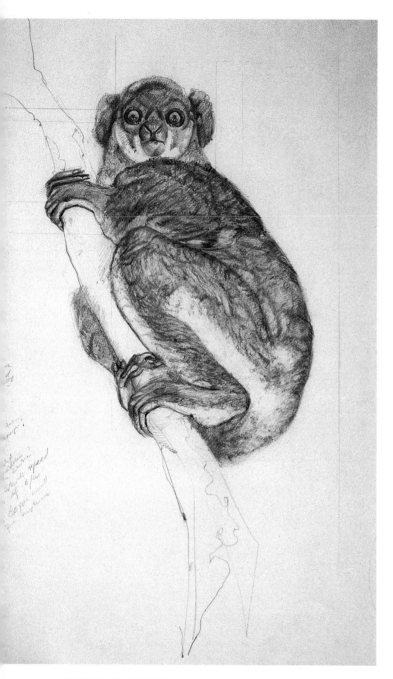

DEFINING EDGES

Edges mark the boundaries between elements of your drawing, such as the "line" distinguishing a lemur's ear from the side of its head. I put the word "line" in quotations because there is no such thing as a line in nature—all objects, even the filaments of a spider's web, have form.

A sharp edge makes an object or element appear to be closer; a soft edge seems farther away. Edges must develop along with values to define form. Contrast in both values and edges commands attention. The area where the lightest light meets the darkest dark with the sharpest edge will be the most eye-catching. Remember this as you develop your center of interest. When shading, use what you see in conjunction with your knowledge about edges. Exaggerate what comes forward to achieve three-dimensionality.

We all want our work to look like the figure studies of Michelangelo or Leonardo. These master drawings seem so effortless, but they were created after years of meticulous studies. "Studies" is the operative word here. The masters initially relied on slow, careful studies of the figure.

Learn to allow all the time you need to get it right. Go over and over the drawing making corrections. It's ironic that many slow studies will increase your drawing speed dramatically. By taking the time to look and study, you'll become adept at knowing what is important and how to get it on paper quickly.

WOOLLY LEMUR

22 x 15 inches (56 x 38 cm)

Define the features by concentrating on the details (small shapes) surrounding them.

I drew this lemur for a book from a photo supplied by the book's scientist author. While I greatly prefer not to work exclusively from photos, occasionally it's necessary. All the same art principles apply to working from a photo as to any other source.

Caribou

Caribou are great northern wanderers whose large clopping hooves keep them from foundering in snowpack and bog. They are the only deer species whose females have antlers, with which they defend vulnerable calves from wolves and bears. The caribou is an elegant and enduring symbol of the Arctic.

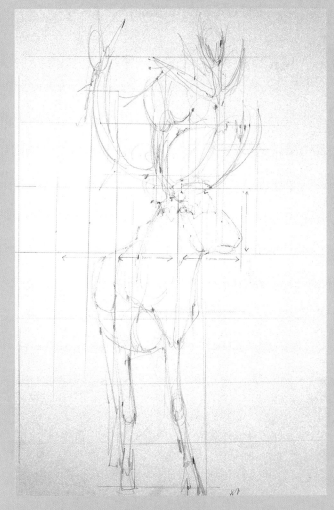

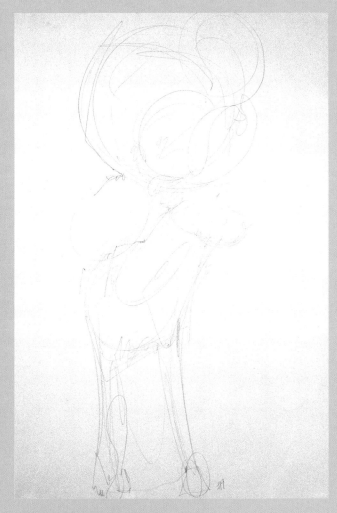

GESTURE SKETCH
The pencil flows quickly from antler to foot to the body to establish attitude, size, and position.

FIRST MEASUREMENTS
You have a rough shape for the head already gestured in. Measure its height with your pencil, then carry that measurement down the paper. If the "head count" happens to match the one you took from the subject, great. Probably it will be off—remember, your gesture sketch is not supposed to be accurate. Simply adjust the size of the head to be larger or smaller until the number of heads in your sketch matches the correct head count.

Hold your pencil up again and measure your subject's head from side to side, then turn the pencil to measure how many widths of the head fit into the height of the head. This will allow you to sketch the outline of the whole head fairly accurately.

Use your T square to draw a vertical line down each side of the head for the full length of the drawing; position your triangle up against the T square and draw horizontal lines at the top and bottom of the head.

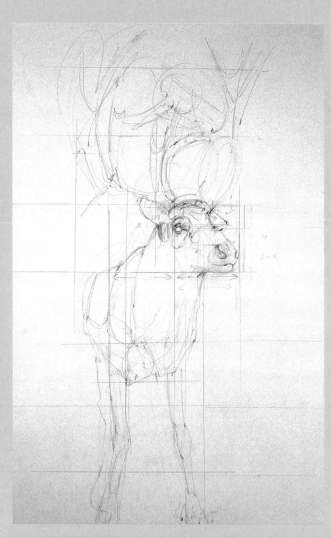

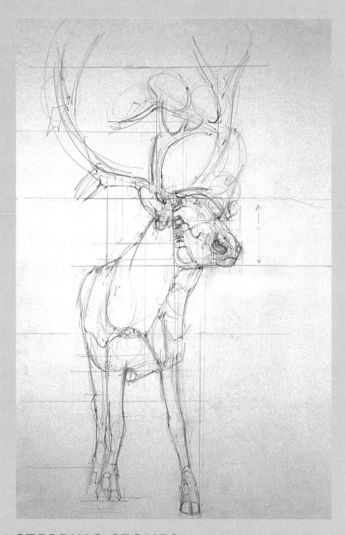

MORE COMPARISONS

You've made a box around the head: This allows you to judge the head's tilt. Hold your pencil up vertically next to your subject's head on each side, and look down to find the parts of the body directly in line with the pencil (in this example the inner edge of the subject's left foot.). Measuring the head again, move your pencil down to count how many "heads" lie between the bottom of the head and the foot (not quite four heads).

Repeat these measurements on your drawing, making a small mark where each new element should be. For example, show where the knee and the ankle each fall directly below the right side of the head. Slide the triangle down and draw a horizontal line across the drawing in each of those places.

Make sure that the placement to the right and left is correct, using the same system to measure how many "heads" lie between your vertical lines next to the head. For example, measure the number of "heads" between the line at the right edge of the head the center line of the left front leg.

Block in the rest of your drawing in this way.

STEPPING STONES

Build up your structure of small shapes, moving outward from the eye. Mosey through all the contours from the eye to the nose. In your mind try to feel the pencil actually touching your subject, tracing every contour of eyelid or tear duct. Each little change of angle or mark on your subject is a landmark that you will draw. It's during this process that you really get to know your subject intimately.

VALUES AND EDGES

Build up tones gradually, keeping the whole in mind. Start with the larger planes, saving details for last. Sharpen edges and increase contrast in the caribou's right ear, antler, and nostril to bring them forward. Maximize contrast and detail in the eye, which is your center of interest. Leave distant areas of the neck, left antler, and left ear pale and undefined; blot with your kneaded eraser to lighten and soften if necessary.

CARIBOU
20 x 15 inches (51 x 38 cm)

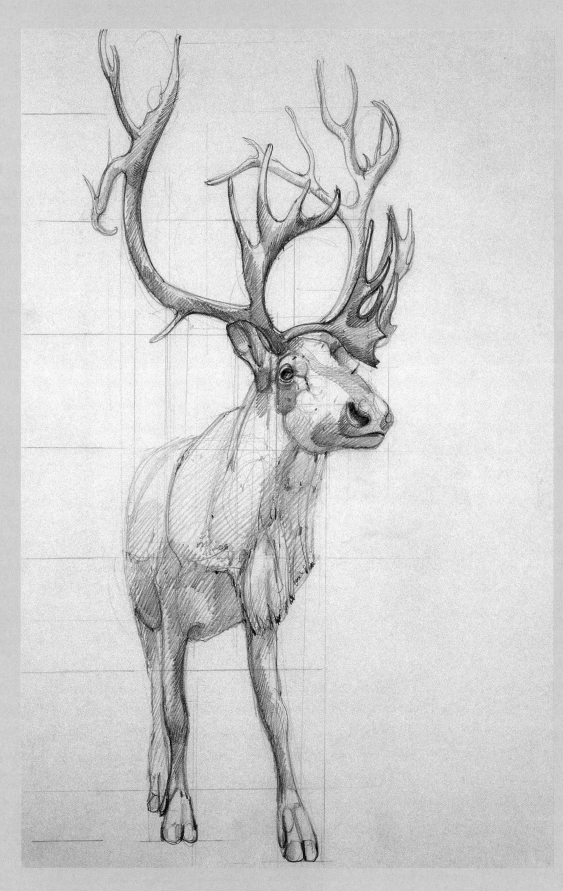

Gorilla

Gorillas are powerful, dignified, and highly intelligent. They are essentially peaceful creatures that don't even defend territories. Humans are the only enemy of gorillas, destroying their forests and hunting them to the edge of extinction.

The gorilla I chose for this demonstration is Bushman, famous longtime resident of Lincoln Park Zoo in Chicago, now preserved at the Field Museum. Bushman's intelligent, brooding eyes gleam from deep shadows beneath a jutting brow. To me, his expression is one of both great power and of loss. Tonal value is my strongest tool in conveying these qualities.

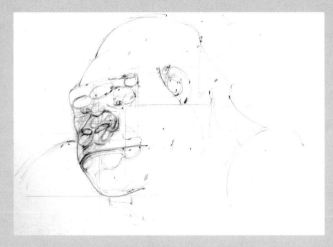

STEPPING STONES
After you've done a gesture sketch and made initial measurements, find the stepping stones, or small puzzle pieces, that will hold the whole face together.

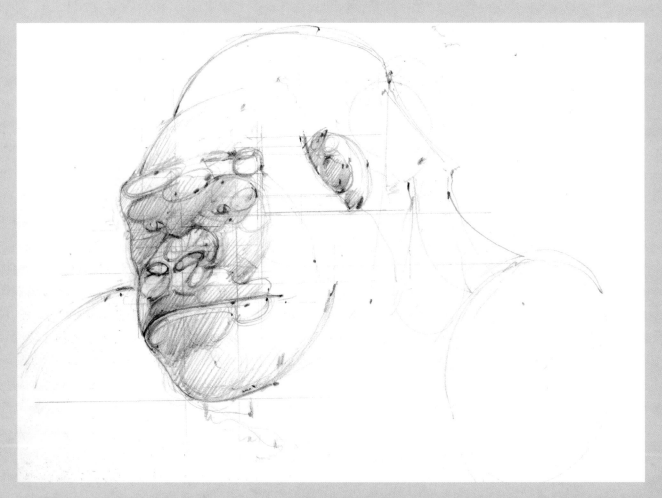

INITIAL SHADING
Begin shading lightly, working from general to specific. As with the initial drawing, break the shaded areas into smaller and smaller chunks.

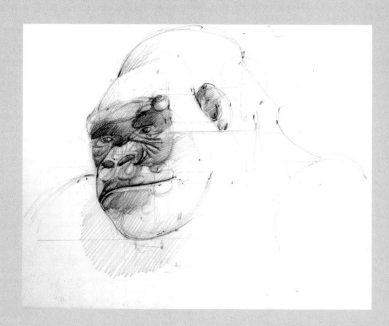

VALUES AND EDGES

Continue shading to include light, middle, and dark tones. Finally add the darkest accents. Sharpen edges and increase contrast where you want the viewer's eye to linger.

FINAL TOUCHES

Check for full tonal variation and subtlety and look closely for expression, touching up where necessary. Strength, expression, and tone are all entwined in this piece.

BUSHMAN
22 x 30 inches (56 x 76 cm)

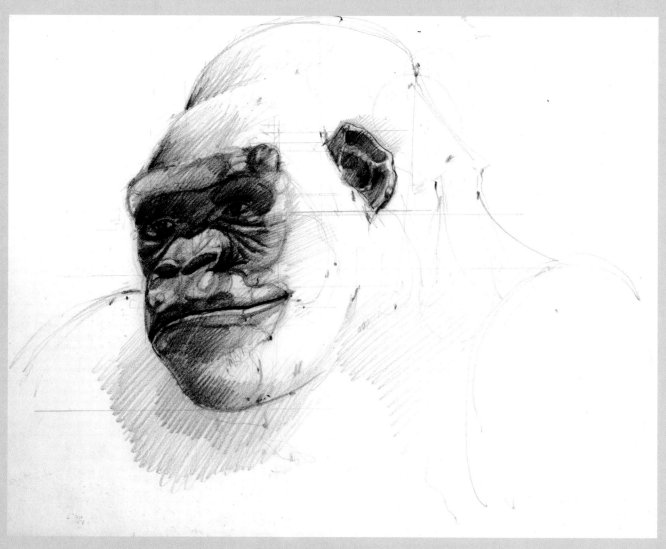

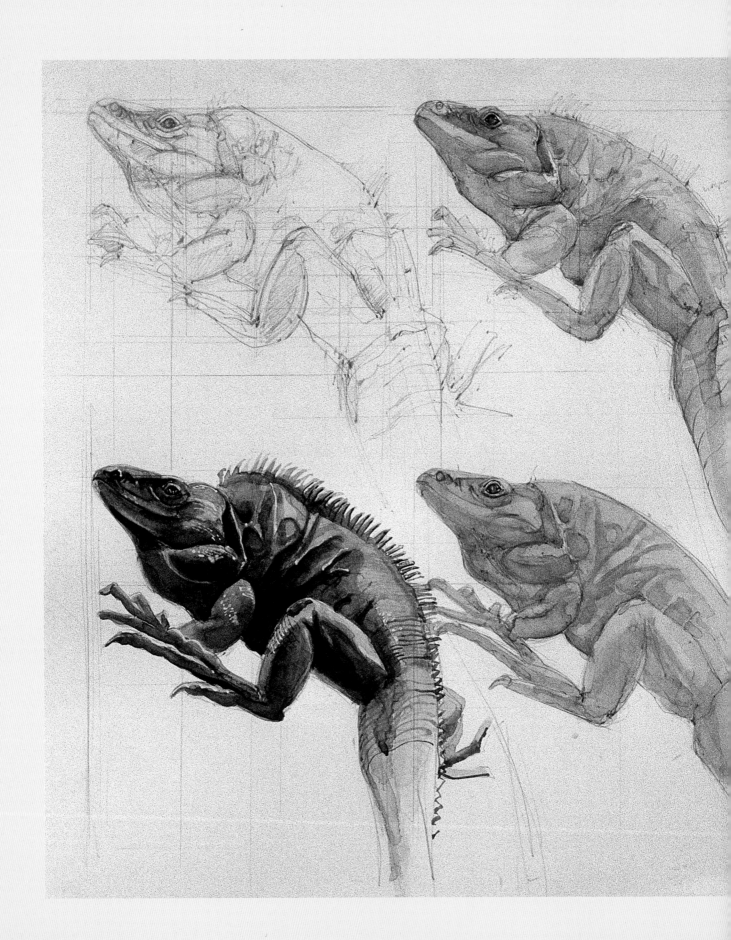

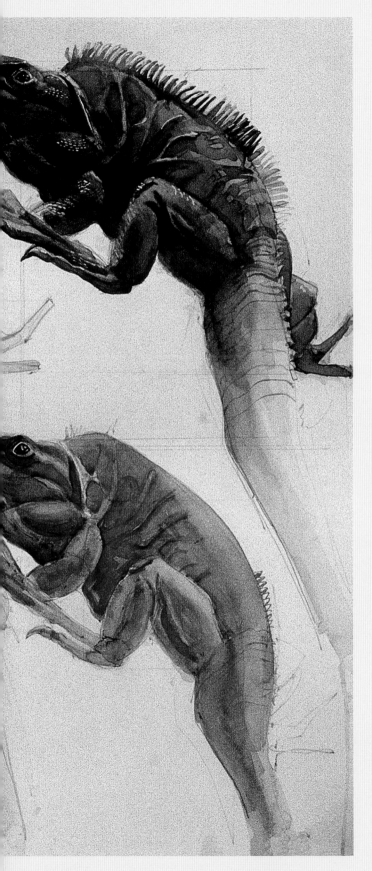

Color

My gradual painting process is inherently individual. Your own "color personality" will emerge in a natural and inevitable way as you paint. You'll find great joy in exploring color—a lifetime of growth.

There are two major color issues you will face as a nature artist. The first is achieving authentic, on-the-nose color that does justice to your subject; for this you need the right palette. The second is recreating the spectrum of living, glowing neutrals that encompasses most of nature. Color mixing is the key. In order to mix color successfully, you must understand a few basic principles.

SPINY-TAILED IGUANA
22 x 30 inches (56 x 76 cm)
The top row of this study page represents three stages of a realistic rendering: pencil drawing, first wash, and finished piece. The bottom row shows three possible color treatments. Your color can be as authentic or as fanciful as you like.

COLOR VERSUS VALUE

How important is color? For hundreds of years different schools of painting fought over its significance, often advocating extremes. One declared color inconsequential, value everything. The Impressionists claimed that finely tuned color with suppressed values produced the greatest visual vibrancy. Which one was right? Both.

Value gives strength to your painting—it makes the owl on your page look three-dimensional. It can be measured and judged as right or wrong. Color has emotional impact and is gloriously subjective. We respect value, but we fall in love with color.

My method of painting with watercolor builds value and color at the same time, so there's no conflict. Phew!

When I first began painting, I concentrated on value because color confused me—I thought you had to be born a colorist. Now I believe that we are all colorists, as good as the time we spend nurturing our individual color sense. You make color choices every day with your wardrobe and your home. Just as we all choose different colors to wear, we also use color differently in our paintings. You and I could paint the same animal, both effectively, and still end up with strikingly different colors.

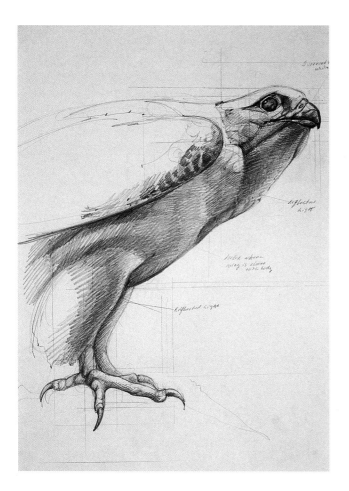

PEREGRINE FALCON
30 x 22 inches (76 x 56 cm)
While the black-and-white drawing of the falcon is strong, your eye immediately goes to the color image.

ACHIEVING AUTHENTIC COLOR

There are three primary colors, or hues: red, yellow, and blue. These colors cannot be created by mixing; they must be purchased. Combining two primary colors produces a secondary color. For example, mixing red and blue creates violet. The secondary colors are orange, green, and violet. (See "Color Mixing" on page 66.)

Colors are referred to as either warm or cool. Red, yellow, and orange are warm colors, and blue, green, and violet are cool colors. However, there are warm and cool versions of all colors. Some blues are warmer than others, and some reds are cooler than others.

To achieve precise colors, you need to paint with a palette that includes a warm version and a cool version of each of the three primaries, backed up with a few specialty colors. I learned this simple guideline from my grandfather when I was about seven years old, and a favorite art school instructor reiterated it years later. This advice has never failed me.

Precise color is a special concern when painting brilliant birds, butterflies, or flowers. Even when not bound to scientific accuracy, you'll seldom want to portray a vivid poppy or monarch butterfly in dull, dirty oranges.

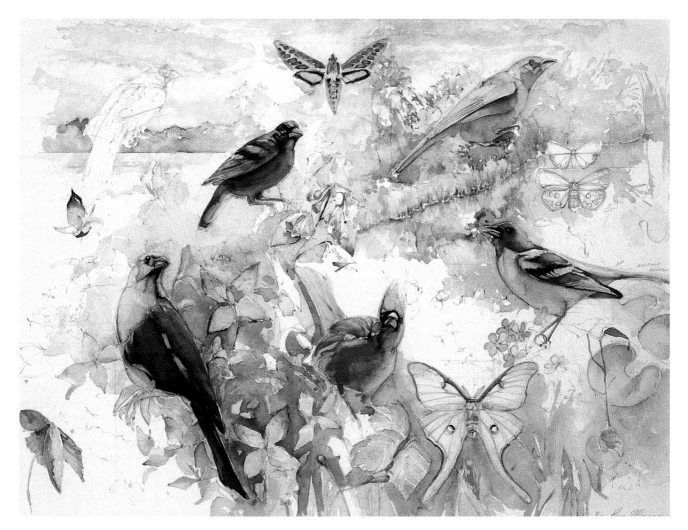

BIRDS AND BUTTERFLIES OF ILLINOIS
22 x 30 inches (56 x 76 cm). Collection of Dorothea and Michael Tobin.
The pure, vivid colors of the Baltimore oriole and the scarlet tanager had to be precise—a dull approximation wouldn't do them justice.

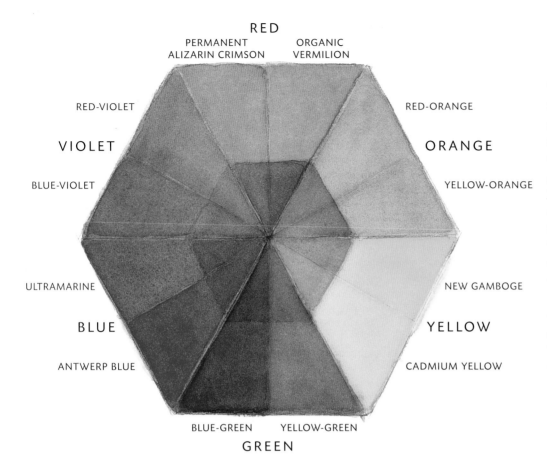

RED
PERMANENT ALIZARIN CRIMSON | ORGANIC VERMILION
RED-VIOLET
VIOLET
BLUE-VIOLET
ULTRAMARINE
BLUE
ANTWERP BLUE
BLUE-GREEN | YELLOW-GREEN
GREEN
RED-ORANGE
ORANGE
YELLOW-ORANGE
NEW GAMBOGE
YELLOW
CADMIUM YELLOW

This color wheel shows two versions of each primary and secondary color. Using a warm and a cool color for each of the primaries (red, blue, and yellow) will allow you to mix clean, bright secondaries (green, orange, and violet). Look across the color wheel to find any color's complement. When mixed, a color and its complement produce gray. The grayed colors in the center of the wheel are the result of these mixes.

THE DOUBLE PRIMARY PALETTE

Painting from a standard three-primary palette consisting of one red, one yellow, and one blue will produce dingy, disappointing results. This is because the painter's primaries of red, yellow, and blue are never pure—all paint colors "lean" to one side or the other on the color wheel, toward either cool or warm.

Let's say that I use ultramarine for my only blue. Ultramarine contains a bit of red, and so "leans" toward violet. This means it mixes well with red for a very nice violet, but what happens when I mix it with yellow to get green? The result is very gray and murky, because the red in the ultramarine is the complement of green—the color on the opposite side of the color wheel. Mixing a color with its complement always grays it. Therefore, if I'm painting a bright green parrot, I need another blue to mix with yellow for the parrot's plumage—a blue that contains no red but is biased instead toward yellow. Antwerp blue or thalo blue will work nicely.

This leaves us with a double primary palette. My usual choices for pairs of primary colors include Antwerp blue (cool) and ultramarine (warm) for blue; cadmium yellow (cool) and new gamboge (warm) for yellow; and permanent alizarin crimson (cool) and organic vermilion (warm) for red.

OTHER COLORS

Most secondary colors can be mixed from these primary pairs. However, all paints contain impurities (other colors in minute amounts), which means that any time you mix colors, the resulting color is a bit dulled. Therefore, I add a few brilliant "specialty colors" to my palette, vibrant paints that are impossible to create by mixing. These include cobalt violet, thalo crimson, and thalo violet.

Finally I use a few "convenience" colors such as sap green, cadmium green, Payne's gray, and burnt sienna. These could be mixed from other colors, but it saves time to buy them directly.

CREATING LUMINOUS NEUTRALS

While it is essential to be able to mix pure hues, the fact is that nature displays itself mostly in neutral colors. Animals would usually prefer not to be seen. To be highly visible often means becoming someone else's dinner. Even predators don't want to be spotted prematurely by a potential meal. Most animals cloak themselves in "stealth" colors of gray and brown to be inconspicuous. Some creatures do throw caution to the wind and display themselves with brilliant abandon (often to warn predators that they are poisonous), but their colors are low intensity when in shadow.

INTENSITY

Intensity, or saturation, refers to the brightness or dullness of a color. The most intense color is one that has not been altered by the addition of other pigments.

Adding black will of course darken and gray any color, but in a dull, deadening sort of way. Don't do it. Instead, combine a color with its complement, which is located directly opposite on the color wheel. A pair of complementary colors contains all three primary colors. Mixing two complements (in other words, all three primaries) creates a rich, luminous neutral.

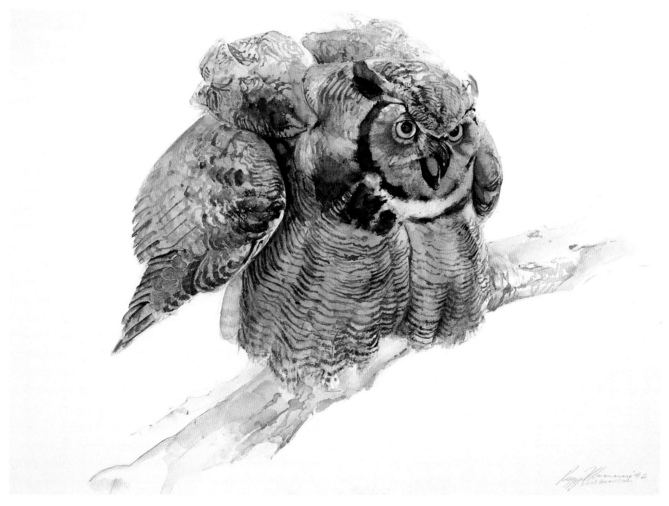

GREAT HORNED OWL
22 x 30 inches (56 x 76 cm)
While the colors used to depict this owl are all of low intensity, the overall effect is not dull.

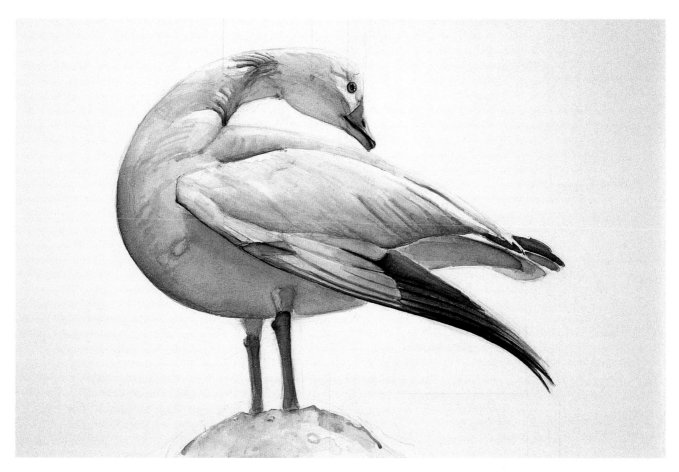

ROSS'S GOOSE
22 x 30 inches (56 x 76 cm). Collection of Mrs. Joseph K. Luby.
*Although this goose's local color is white, there is little white
left in her plumage. Her form is made up mostly of shadows
painted in quietly glowing, muted blues, pinks, and violets.*

A RANGE OF GRAYS

The color of an object, unaffected by light and shadow, is
its local color. But to appear solid, an object must include
light, medium, and dark tones (see "Establishing Values,"
page 29).

Whether you're painting a white goose, the gray-
brown fur of a deer, or the muted shadow side of a bright
parrot, the secret is to use a range of grays, not just one.
These grays will whisper to one another, keeping the
quiet areas alive. Neutral does not mean boring—there
really is no such thing as a "plain" gray. Try the exercise at
right with your hand and remember to include more
than one grayed color in any given shadow area.

My method is one of many layers, which makes neu-
tralizing easy and natural. The chart on the next page
shows that regardless of which color you begin with, af-
ter ten layers of other colors you'll arrive at a dark, lumi-
nous neutral with many quietly vibrant stages in between.
It's very important to let the paint dry between layers.

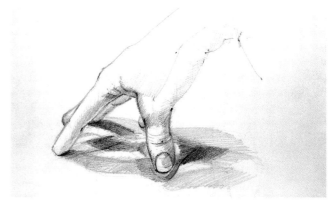

*Try this simple experiment: Place your fingertips on a white surface,
under a strong light. Stare at the shadow cast by your hand for a
full minute. It will soon be apparent that the "plain" gray shadow
is really a mixture of subtle violets, yellows, blues, and pinks.*

Here I first painted swatches of red, yellow, and blue, then added layers of other colors in random sequences. In each case, the result is an increasingly darker neutral, a great deal more interesting than the colors you would get by mixing in black.

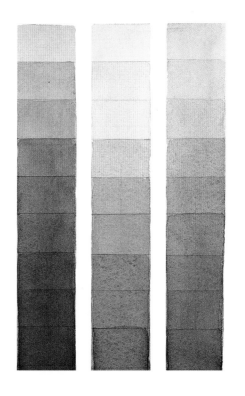

OSPREY

22 x 30 inches (56 x 76 cm)
See how a color and its complement, in this case red and green, combine to create a neutral. It's important not to mix too thoroughly—leave a bit of each original color showing through. Let the viewer's eye do the mixing.

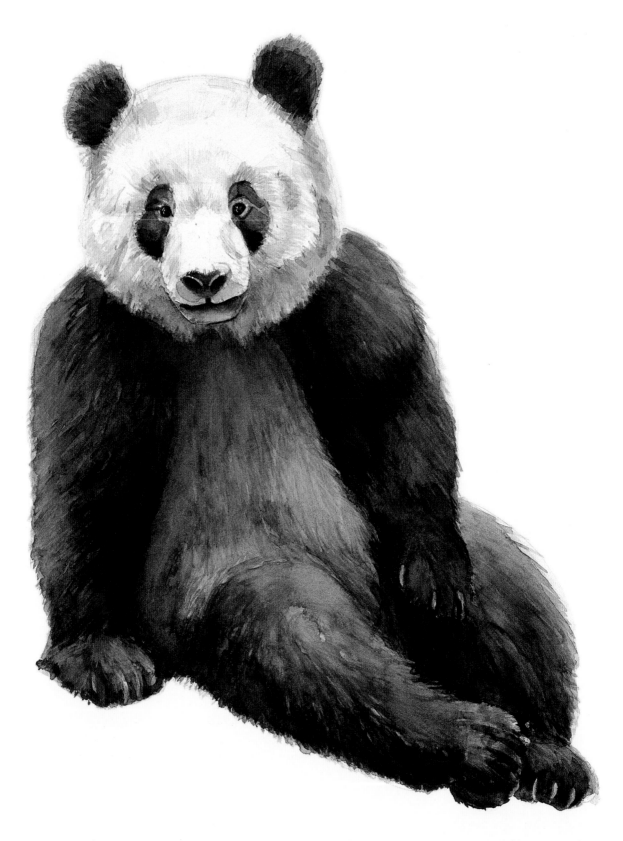

CREATING DEPTH

Warm colors—think "fire" (red, orange, and yellow)—pull forward and generally draw the eye first. Cool colors—think "water" (blue, green, and violet)—push back into the distance. Use this "pull and push" principle to create depth and volume in your painting. Use warmer colors in the areas of your painting that you want to appear closer to the viewer, and where you want to attract and hold the viewer's eye. Use cool colors in receding areas and in places you want the viewer's eye to pass over more quickly. Another way to make colors "pop" or recede is by the careful placement of other colors next to them. Think of the warm and cool colors as the yang and yin of your painting. Yang energy is warming and active, and is associated with the sun; yin is cooling, nurturing, and associated with water. They must be balanced.

MAKING COLORS "POP"

When the eye and the brain encounter a color, after a short while they automatically generate the color's complement around the edges. When the viewer looks away into a blank spot, a complementary color image appears there as well. The Impressionists made great use of these remarkable phenomena, known as simultaneous and sequential contrast.

This is a neurological happening—why does it matter when you're painting wildlife? When you provide both a color and its complement in a painting, you're essentially creating an effect the viewer's brain was about to generate for itself. This causes the colors to vibrate, bringing them to life. If I need an area to "pop," once I apply a color, I immediately lay its complement down next to it.

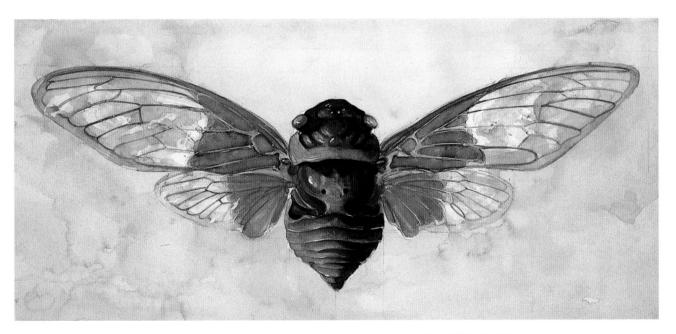

CICADA FROM ECUADOR
15 x 30 inches (38 x 76 cm).
Collection of Barbara and Michael Heaton.
Notice the warm yellows on the light side of the body, and the cool blues on the shadow side as the form turns away.

GIANT PANDA
30 x 22 inches (76 x 56 cm)
The neutral colors of this panda are made up of many layers of a variety of pure colors, which mixed on the page.

Stare at the three images of the cardinal for a full minute. At the end of that time, you should see each color's complement (green for red, orange for blue, and violet for yellow) vibrating around the image's edges.

Stare for another minute, then look at the blank white area to the right. You'll see a complete afterimage of the figures, each in its complementary color.

PLAYING DOWN COLORS

Sometimes you will want to achieve the opposite effect: Instead of emphasing a color, you may want to tone it down. Analogous colors are those that are close to each other on the color wheel, such as blue and green or red and orange. Placing them next to each other has the opposite effect of using complementary colors. If you want to de-emphasize a color without actually graying it, lay analogous colors next to the offendingly bright color.

LEAF INSECT (GENUS *PHYLLUS*)
22 x 15 inches (56 x 38 cm)
Notice how the complementary red background makes this green insect come to life, popping him forward.

Warm yellows and reds bring the light upper area of the alligator's tail forward; cool analogous blues and greens make the shadow area recede. (See the full painting on page 134.)

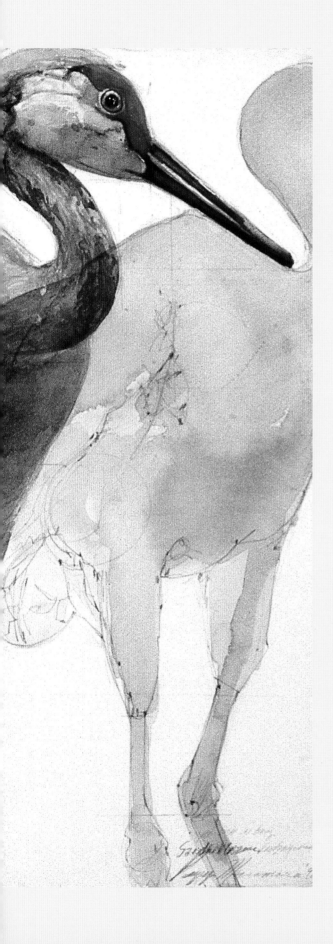

Design

Design refers to the arrangement of subjects on the page. The eye and mind crave good design—an expertly rendered painting of a beautiful subject will fail to please if it is poorly designed. Looking at an unbalanced design within a painting can be as uncomfortable as seeing a crystal vase perched on the very edge of a shelf. In each case we get an unpleasant, almost physical feeling of impending disaster. A balanced work, however, satisfies the eye and mind. In my teaching I've found that about 15 percent of the population has an excellent natural sense of design. But for the rest of us, a few guidelines are helpful.

SANDHILL CRANES
22 x 30 inches (56 x 76 cm). Collection of Janet and Brian Avery.
Repitition and echo contribute to a striking design that goes beyond portraiture. The fading images are a visual representation of the fact that sandhill cranes are endangered.

PLACING YOUR SUBJECT

Your basic starting place in any painting is the rectangle of the paper. The simplest form of design is to place a single subject within that rectangle. There are two guidelines you should follow to place the object most effectively. Avoid the "bull's-eye" effect created by placing your subject in the center of the page, and generally choose asymmetrical designs over symmetrical ones. Although symmetry conveys a sense of peace and stability and is often used in religious art, asymmetrical images project more action and interest. Compositions containing more than one subject follow the same rules. Your goal is to arrange your multiple subjects into a single, cohesive whole.

See how cropping an asymmetrical image (below) to be symmetrical results in a much weaker design.

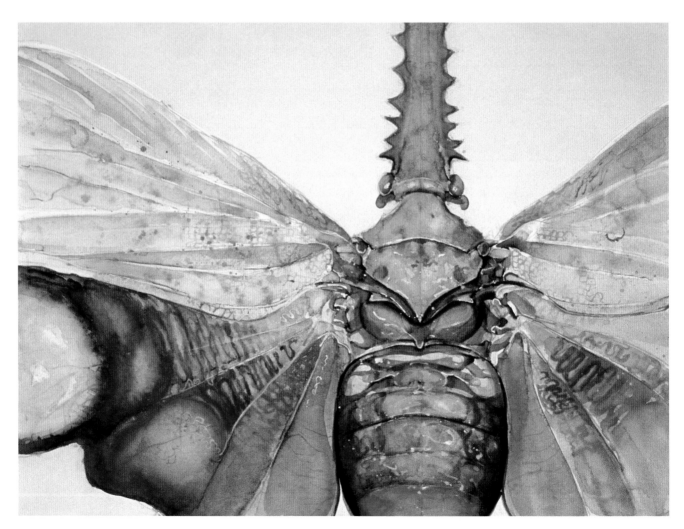

FULGORID BUG (ORDER HEMIPTERA)
22 x 30 inches (56 x 76 cm). Collection of Mary Arlene and William Stecher.
The asymmetrical position of the insect in this painting makes an interesting and strong composition.

Focal Point

The focal point of your painting is the area where you want to draw the viewer's attention. As I said above, you should avoid placing your focal point in the center of the page. Here's a quick formula for good basic placement of your focal point: Draw a diagonal line across your rectangle, then a perpendicular line from it to either of the opposing corners. Repeat on the other diagonal. The points where the perpendicular lines begin are natural resting places for the eye, therefore good spots for your center of interest. But remember, any formula is just a starting point. Don't adhere slavishly to this or any other formula. Your focal point is balanced by other elements in your painting, so you always need to consider the whole.

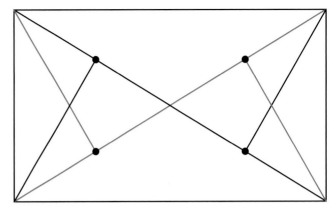

Consider choosing one of the four marked points to place the focus of your painting. But notice that my compositions often don't follow this or any other formula.

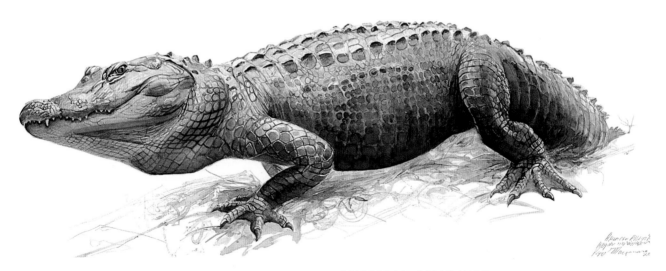

AMERICAN ALLIGATOR
24 x 60 inches (61 x 152 cm)
In this painting I wanted the alligator's head to be the focal point, so I placed it in the area where the diagonal and perpendicular lines meet. While the majority of my paintings don't necessarily follow this or any formula, it's a good place to begin if you're unsure.

IMPACT FROM A DISTANCE

Every successful painting begins as an interesting set of shapes, well arranged, that works on an abstract level even before the subject becomes identifiable. Think of this concept as "impact from a distance"—the idea that a painting should be intriguing from across the room, or from too far away to tell what the subject is. This is the essence of strong design.

To achieve effective impact it helps to begin a piece by drawing a rough thumbnail sketch (about 2 by 3 inches/5 by 8 cm) that sets the basic arrangement of the shapes while there is still time to alter the composition.

This 2- by 3-inch (5- by 8-cm), two-minute pencil thumbnail sketch establishes an interesting set of shapes. Notice that the far wing is cropped, as is the tip of the near wing. This placement anchors the shapes within the format in a satisfying way.

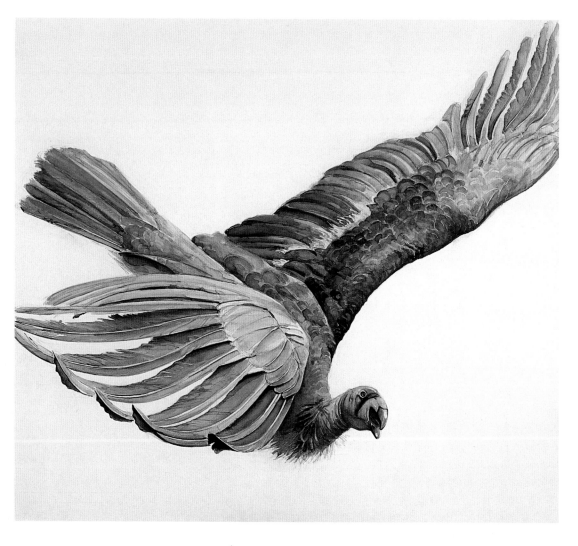

DESIGN PRINCIPLES

Several considerations affect the design of your painting. These include unity versus conflict, direction and movement, repetition, emphasis, and color. All of my paintings employ a number of design considerations to a greater or lesser degree. Don't worry about memorizing a list—you'll use a lot of design tools unconsciously. But keep them in mind in the planning stages of a piece, and refer to them later if something seems wrong even when you have used good drawing and painting techniques. Use these principles with a sense of fun. Play with them in the form of thumbnail sketches before committing to a finished painting.

UNITY VERSUS CONFLICT

All good designs need unity (harmony) to hold the piece together and prevent a feeling of chaos; yet they also need enough conflict (contrast) to be interesting. Sounds a lot like life, doesn't it?

There's a feeling of unity when all elements work together—when they're related by shape, color, or subject matter, for instance. Conflict steps in when an element no longer fits—when it contrasts noticeably. You usually want enough unity to create a comfortable visual/psychological environment, and enough contrast to allow one element to dominate and become a focal point.

TRUMPETER SWAN
22 x 15 inches (56 x 38 cm).
Private collection.
This cropped close-up has a naturally abstract quality that helps to tie all of the elements together. Using similar colors and values provides unity as well.

CALIFORNIA CONDOR
30 x 34 inches (76 x 86 cm)
With the design firmly in mind I can draw and paint my subject with confidence. There will always be more subtle design decisions along the way—where to provide unity, increase contrast, and so forth—but my basic design will guide those decisions.

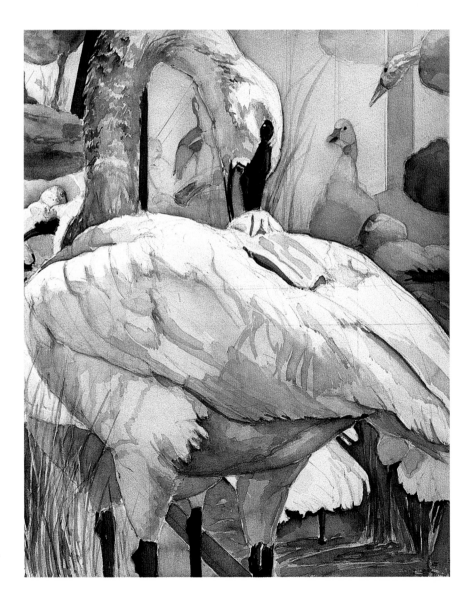

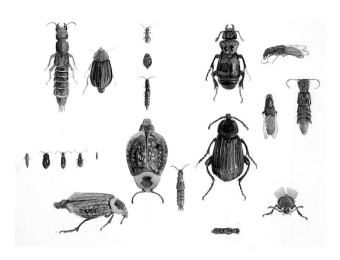

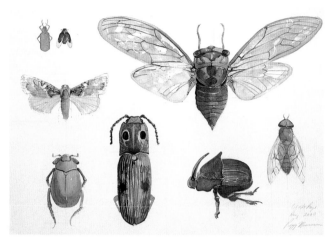

INSECT PAGE WITH ROVE AND CARRION BEETLES
22 x 30 inches (56 x 76 cm). Courtesy of Aron Packer Gallery.
Placing subjects asymmetrically on the page is so much more interesting and pleasing to the eye than a symmetrical design.

INSECT PAGE WITH DOGDAY CICADA
22 x 30 inches (56 x 76 cm). Courtesy of Aron Packer Gallery.
The dogday cicada on the upper right anchors the page, and the direction of the small insects leads the eye down, around, and back up to the cicada.

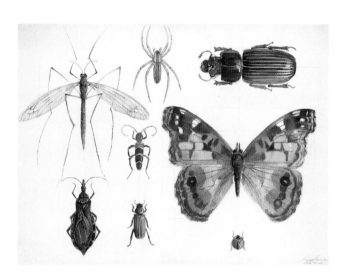

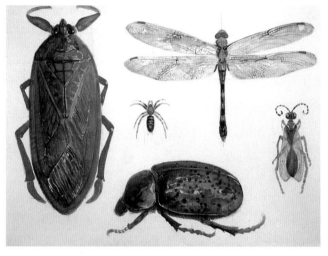

INSECT PAGE WITH PAINTED LADY BUTTERFLY
22 x 30 inches (56 x 76 cm). Courtesy of Aron Packer Gallery.
Unity of subject matter and color brings a pleasing sense of order to this page, while the oddness of the insects makes it interesting.

INSECT PAGE WITH WATERBUG
22 x 30 inches (56 x 76 cm). Courtesy of Aron Packer Gallery.
The waterbug dominates this painting with size and value, contrasting nicely with the dragonfly's delicate wings.

SNOWY EGRET
22 x 15 inches (56 x 38 cm).
Collection of Carmel and Thomas Cowan.
The size difference between the egret and the dragonfly lends an interesting contrast to the composition. Make size variations substantial; subtle differences are somehow merely annoying. The echoing colors throughout create harmony.

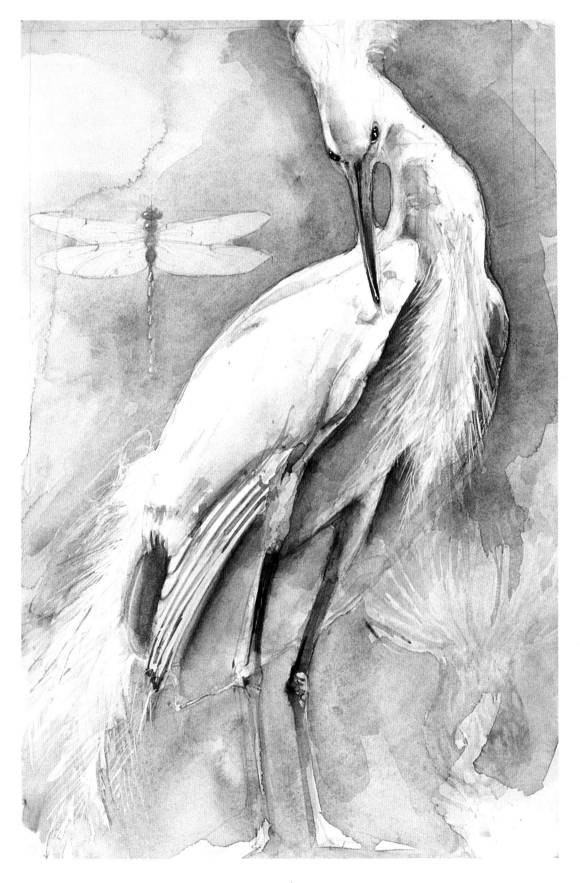

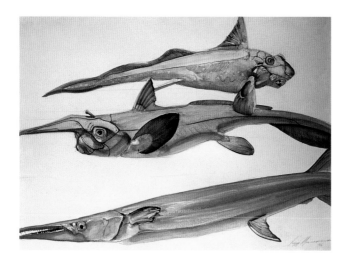

DIRECTION AND MOVEMENT

A good artist guides the viewer's eye with direction and movement. You don't want your viewer to get stuck in one area of your painting. You can avoid this through careful placement of the elements of the composition. These elements can act almost as arrows, pointing where you want the viewer to look.

You'll want to consider bringing the viewer into the painting with "lead-ins," which guide the eye to the center of interest. Keep the viewer inside the painting by avoiding "lead-outs," which draw the eye away from the center of interest.

THREE FISH
22 x 30 inches (56 x 76 cm). Private collection.
The implied motion and alternating direction of the fish (from top to bottom: ratfish, long-snouted chimaera, and houndfish) bring the elements of movement and direction into this piece. The unequal spacing and cropping also help make this painting a successful design even outside of its representational merits.

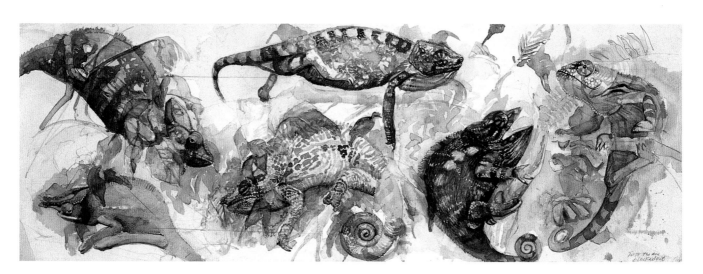

CHAMELEONS, MADAGASCAR
15 x 40 inches (38 x 102 cm). Courtesy of Aron Packer Gallery.
Notice how the somewhat curling shapes of the chameleons provide the viewer's eye with a "lead-in" and guide the eye to the center of interest. Finally a "gatekeeper" chameleon at the right edge prevents the eye from leaving the painting.

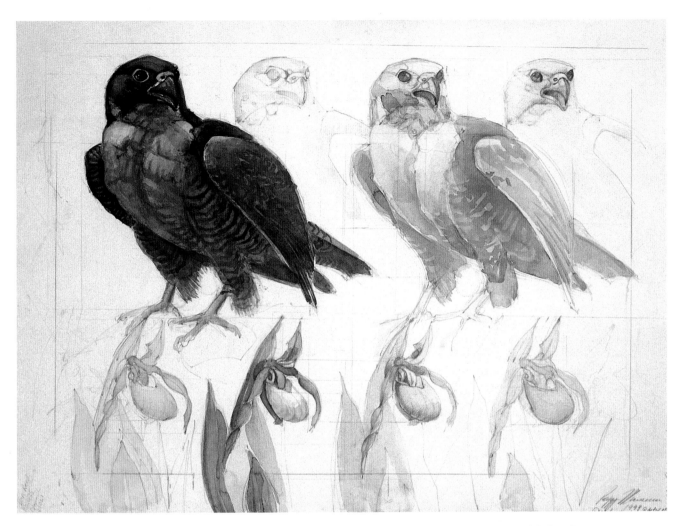

PEREGRINE FALCON AND ORCHID
22 x 30 inches (56 x 76 cm). Courtesy of Aron Packer Gallery.
In this painting, repetition is very overt, while value and color variations create a more subtle rhythm. Notice how having one element dominate makes it a stronger piece.

REPETITION

Repetition, or echo, is a great way to establish harmony and keep the viewer's eye moving through the painting. Echo your colors—when you apply a color in one place, make sure that you use it in several other areas too. Let shapes and lines repeat as well.

The use of reflections can help create a cohesive design by literally echoing the principal colors and shapes of a composition.

EMPHASIS

It sounds obvious, but in a painting that contains a number of elements, one element should dominate. There are several different ways in which you can emphasize an element. The simplest way is to make it larger. You can also emphasize an element by painting it with stronger values, harder edges, or more intense color.

COLOR

Think of color as a design element that guides the eye (see "Creating Depth" on page 44). Warm colors pull forward, attracting the eye first, so you can lead your viewer with a trail or pattern of warms. You can do the same with a pattern of cool colors that fall back. As I mentioned above, repeating a color throughout a painting helps to establish harmony.

Another color tool is the use of an idiosyncratic or unexpected color treatment, which can surprise and delight, causing the viewer to look at the subject in a new way.

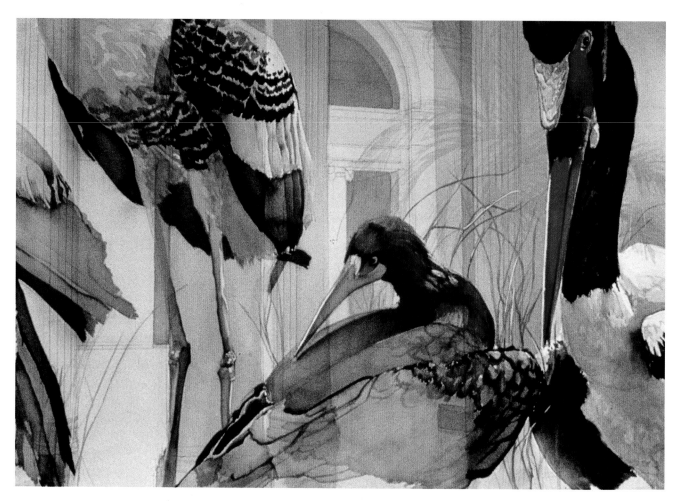

BIRDS OF SOUTH AMERICA
30 x 40 inches (76 x 102 cm).
Collection of the Field Museum, Chicago.
Transparent reflections echo the solid subjects and hold the
design together.

WHITE-TAILED JACKRABBIT
30 x 22 inches (76 x 56 cm)
I used nonrealistic color here to make a different kind of statement
than a more realistic piece would. Repetition also seemed like a very
appropriate design principle to employ for an animal that can
travel in a zigzag pattern at 40 miles (64 km) per hour!

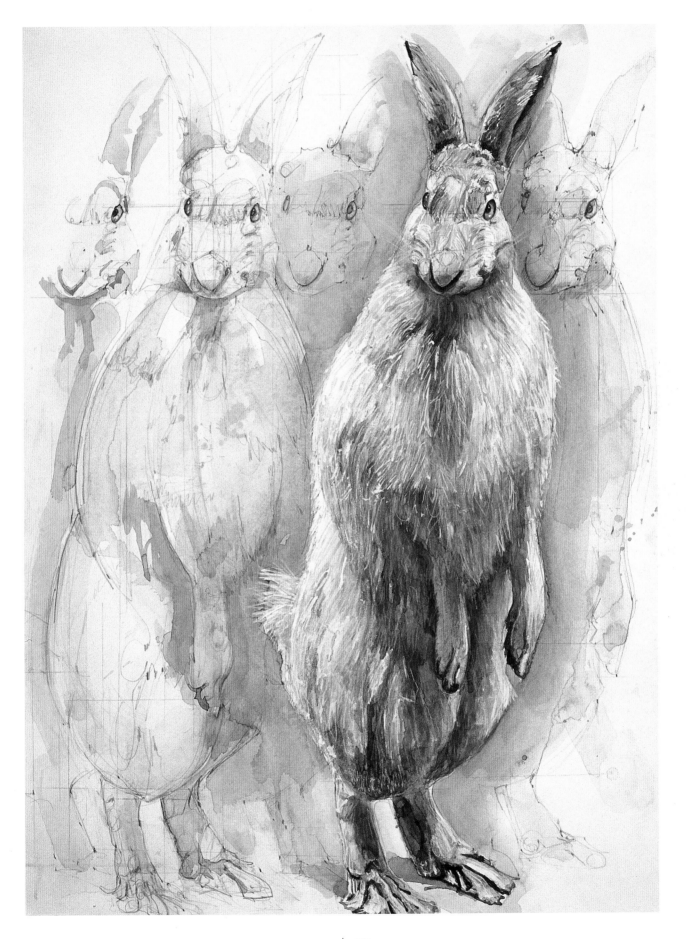

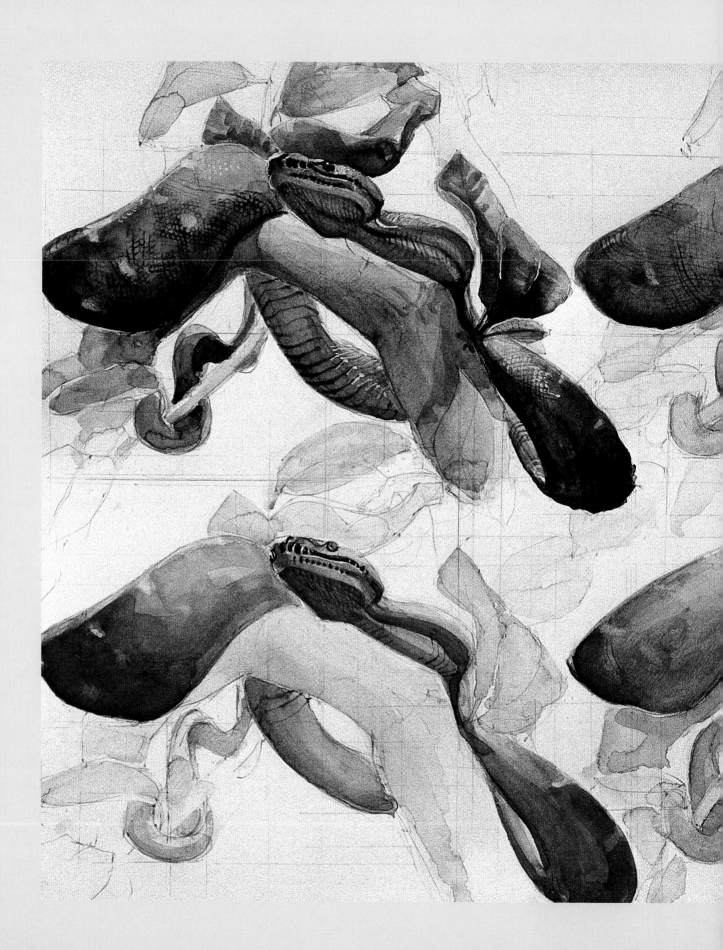

Watercolor Basics

I believe that watercolor offers the greatest versatility and vibrancy of any painting medium. The process itself is fluid and meditative. It is a combination of staying in control and of knowing when to sit back, let go, and allow the paint to interact freely with water and with other paints. Watching paints flow and combine, bloom and separate is so engrossing that your beautiful end product may (almost) feel like merely a nice bonus!

But hang on. Before you reach this Zen-like state, you'll need to learn a few basics.

EMERALD TREE BOA
22 x 30 inches (56 x 76 cm)
The possiblities of watercolor are endless.

MATERIALS

Use good materials. Otherwise, you can never be sure whether a failure is due to your technique or to inferior materials. Using poor-quality paints and brushes is like trying to learn to play the violin on an instrument you made in your basement. Good products do cost more, but when you consider the time and energy invested in your art, they're well worth the price.

PAPER

Watercolor paper comes in three textures—hot-pressed, cold-pressed, and rough. Hot-pressed paper is very smooth, rough has the coarsest texture, and cold-pressed is somewhere in between. A number of manufacturers, such as Lana, Arches, Fabriano, Saunders Waterford, and Winsor & Newton, produce watercolor papers. I use only heavy 300-lb. Lana paper. I usually use hot-pressed paper, but the rougher cold-pressed paper is more forgiving of beginners because it takes a more even wash. Wet washes tend to slide around on very smooth paper. I never use rough paper.

Whether hot-pressed or cold-pressed, Lana's soft, luxuriant finish welcomes multiple washes. Heavyweight paper will not buckle under wet applications, and takes corrections well. It doesn't need to be stretched, merely taped to your drawing board in a few places to keep it from slipping.

BRUSHES

Watercolor brushes come in round and flat shapes. I use nearly all round brushes, but occasionally I use a 1-inch (2.5-cm) flat brush for broad background washes. For years I used Winsor & Newton Series 7 round sable brushes exclusively. The natural bristles taper to a long, springy point; the full belly retains a wealth of water and pigment that you can release with great control. Unfortunately the precise point of sable brushes doesn't wear well, and these brushes need to be replaced often.

Looking for economical options for my students led me to experiment with other brushes. I've found that much less expensive synthetic and natural/synthetic blend brushes work just as well for the vast majority of my work, though there are still times when I need the fine-tuned control that sable brushes provide.

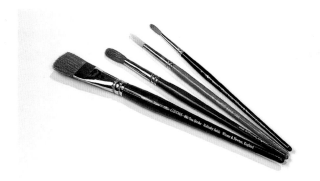

The brushes I always have with me (from top to bottom): No. 4 Winsor & Newton Series 7 round sable; No. 8 White Taklon Round; No. 10 Kolinsky Plus; 1-inch Winsor & Newton Kolinsky sable flat.

Two inexpensive brushes usually carry me all the way through a painting: No. 10 Kolinsky Plus from Crayola (a combination of natural and synthetic bristles) and No. 8 White Taklon Round from United Art and Education.

DRAWING BOARD AND EASEL

I often work with my drawing board and paper on my lap, but this arrangement is usually too awkward for a beginner. Instead, try an aluminum watercolor easel that tilts forward and backward, allowing your paint to flow as needed. Another option is to assemble a homemade equivalent by mounting a piece of Gatorboard (a light, sturdy foam board) onto a photographer's tripod with a universal joint, which can be found at any camera store.

Nearly anything can serve as a drawing board when you're not using an easel, even your portfolio case. Gatorboard works well. I find commercial drawing boards too heavy to carry around.

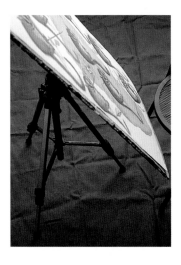

This homemade easel rotates and tilts nearly 360 degrees, giving maximum freedom and control. I usually sit while painting.

PALETTE

Since I mix my colors right on the paper, I use a standard plastic palette with wells. At the beginning of each session I squeeze a pea-sized dab of paint into each well, then add about 2 teaspoons of water. Rather than actively mix it, I let the paint dissolve naturally. That way the surrounding puddle is diluted for the first pale washes, but later can be strengthened by mixing.

As the painting progresses (at about the halfway point), you need to increase the strength of the painting mixture. At first you can just dissolve more of the paint dab into the water with your brush tip, but eventually you may need to add more paint.

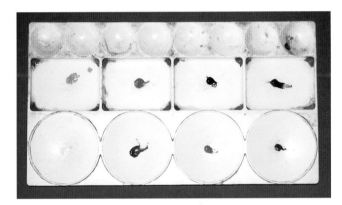

Squeeze just a teardrop of paint into each well of your palette.

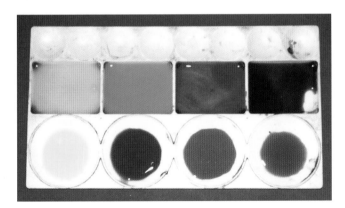

Add about 2 teaspoons of water. Don't mix the paint into the water—let it dissolve gradually.

OTHER SUPPLIES

Use two lightweight water containers—one for cleaning brushes, the other to hold clean water for washes. You'll also need a sponge, rag, or paper towels for wiping brushes. Facial tissues (without lotion!) are useful for blotting excess paint from the paper.

PAINTS

I always use tube watercolors, rather than pan paints, for finished paintings, because I like to mix the paint with water in wells and allow the concentration to vary.

When buying paints, check the label for the ASTM (American Society for Testing and Materials) rating for lightfastness, which runs from I (excellent) to IV (poor). Avoid paints rated III or IV; they may fade in just a few years if exposed to light.

Here is a list of paints I use regularly. All my recommended paints are Winsor & Newton unless otherwise specified. Other brands I've had good luck with include Grumbacher's Finest, Daniel Smith, and M. Graham.

CADMIUM RED
ORGANIC VERMILION (M. GRAHAM)
PERMANENT ALIZARIN CRIMSON
QUINACRIDONE RED
THALO CRIMSON (GRUMBACHER'S FINEST)
CADMIUM ORANGE
CADMIUM YELLOW
NEW GAMBOGE
QUINACRIDONE GOLD (DANIEL SMITH)
TRANSPARENT YELLOW
CADMIUM GREEN
SAP GREEN
THALO (WINSOR) GREEN
ANTWERP BLUE
MANGANESE BLUE
ULTRAMARINE
COBALT VIOLET
DIOXAZINE (WINSOR) VIOLET
THALO VIOLET
BURNT SIENNA
PAYNE'S GRAY

MATERIALS FOR WORKING IN THE FIELD

There are two possibilities here. The first is to bring your regular studio materials, including full-sheet watercolor paper. This provides the most options and works fine if your destination is nearby.

But if you're hiking 8 miles up a steep mountain path, you'll want either more manageable materials or a llama to carry your stuff.

There are many watercolor field kits available; Winsor & Newton is my first choice. If you're just experimenting and are on a tight budget, Crayola or Prang school sets contain remarkably transparent and bright colors (although they may fade in time).

Other in-the-field options include specially made high-quality travel brushes that can be taken apart and reassembled so that the bristles are protected inside the detachable handle. Another fine invention is the Niji Waterbrush—its plastic handle is a hollow barrel that holds water and dispenses evenly, so that you don't have to deal with a separate water container.

Even in the field I often use my usual 300-lb. hot-pressed Lana watercolor paper, cut into smaller pieces and enclosed in two sheets of foam board (which later serve as my drawing board). The lighter 140-lb. paper may buckle somewhat under wet washes but it is less expensive and easier to transport, as full sheets of it can be rolled.

There are also all sizes of spiral-bound sketchpads available, ranging from light drawing stock to those containing professional grade watercolor paper. I'd recommend at least medium-weight paper, which won't buckle outrageously.

Other practical considerations include something to sit on, either a light folding stool or a gardener's kneeling pad, and appropriate dress: layers for the cold, a disposable rain poncho for sudden showers, and comfortable shoes. A wide-brimmed hat, sunscreen, insect repellent, water bottle, and energy bars can also contribute to a good day.

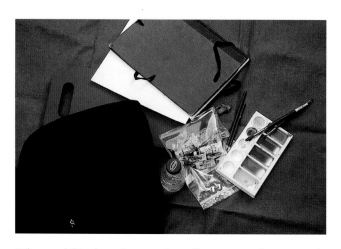

When not hiking long distances, I usually carry a smaller version of my studio set, including a drawing board, tube paints, a palette with wells, and a bottle of water.

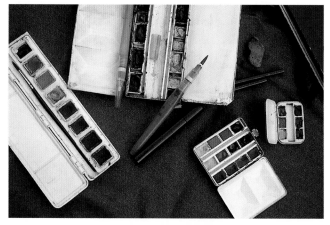

For longer distances I carry a watercolor field kit—the larger the set, the heavier it is. Paint sets from left to right: Crayola, Winsor & Newton, kid's party favor filled with new paints, Schminke.

I'm a big fan of the Niji Waterbrush (center), a great invention that lets you skip the water container. I carry a large and a small waterbrush; both fit inside my Winsor & Newton paint set.

WATERCOLOR PAINT PROPERTIES

Because they lack the heavy binders used in oil, acrylic, and other paints, the pigments and dyes of watercolor are free to express their own unique properties. This allows for a lovely element of serendipity absent in more static media. Learn a bit about these properties and you can use them to great advantage.

The various properties of watercolor paints depend on different paint compositions. They can be either dyes (clear color dissolved in water) or pigments (particles suspended in water). Dyes tend to penetrate the paper, while pigments sit on top.

TRANSPARENCY AND OPACITY

Transparent paints let light, and the layers beneath, shine through. Transparent colors are generally more suitable for layering, and you should use them in all early layers of a painting. All dyes are transparent. Most pigments have some degree of opacity.

Opaque paints cover the layers beneath them. They also loosen more easily—if you use them in the initial layers they tend to muddy the layers on top. In final layers, however, you can float them on top where they will sit, their uniquely beautiful colors glowing. Use them to correct mistakes or to cover and freshen a previously drab or murky area. All cadmium colors are opaque.

Transparent paints include:
- PERMANENT ALIZARIN CRIMSON
- QUINACRIDONE RED
- THALO CRIMSON
- QUINACRIDONE GOLD
- TRANSPARENT YELLOW
- NEW GAMBOGE
- SAP GREEN
- THALO (WINSOR) GREEN
- ANTWERP BLUE
- DIOXAZINE (WINSOR) VIOLET

Semiopaque paints include:
- ORGANIC VERMILION
- ULTRAMARINE
- COBALT VIOLET

Opaque paints include:
- CADMIUM RED
- CADMIUM ORANGE
- CADMIUM YELLOW
- CADMIUM GREEN
- MANGANESE BLUE

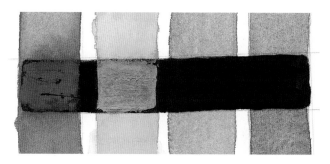

Test colors for transparency by applying them over a black swatch—opaque colors will show on top of the black, while transparent ones will virtually disappear.

STAINING

Staining colors penetrate the paper permanently—even vigorous scrubbing won't lift them. Don't use staining colors on top of opaques. They can sink through, mixing and muddying as they go. To check a new color's staining strength, paint a swatch and let it dry thoroughly. Then moisten a stiff-bristled brush and scrub a part of the swatch repeatedly. If the color doesn't lift, it's a stainer.

Staining colors include:
- PERMANENT ALIZARIN CRIMSON
- THALO CRIMSON
- THALO VIOLET

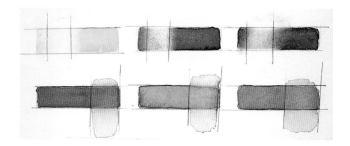

The colors in the top row are nonstaining. I was able to remove the color by scrubbing at the swatch with a stiff brush. The colors in the bottom row did not lift when I scrubbed them—they are stainers.

COLOR MIXING

Color doesn't pop out of your head (or the tube), done to perfection. You have to build color relationships gradually, making changes all the time. By layering color slowly I find myself really looking at both my subject and my painting. Colors can be mixed either on the palette or on the paper. I always mix on the paper, through layering. In layering, every glaze alters the colors underneath. This method imparts a unique luminosity as thin layers build. Color sequence generally has little effect on final color (see illustration on page 43). Yellow is the exception—it needs to be applied first if it's going to read effectively as the local color (the color of your subject in normal light).

Even the strongest of yellows is still light in value—layered over darker values it either doesn't show at all or it looks dingy. In fact there's no such thing as a dark yellow. The shadows of your yellow subject are really some sort of brown or green. The trick is to vary the colors within a shadow area—lean them toward brown in one brush stroke, toward green in the next.

When layering, three factors are more important than sequence:

- Keep each layer light—you can always go darker, but you can't lighten without drastic measures.
- Err on the side of brightness—you can always neutralize, but you'll never regain lost color intensity.
- Let each layer dry thoroughly before applying the next. Pigment from a still-damp layer can loosen and combine with the new layer, often producing mud.

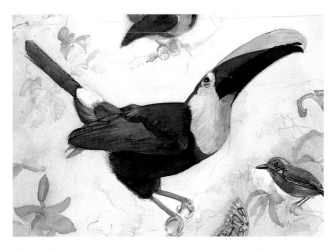

The shadow color on the toucan's breast is made up of varied browns and greens. Remember to lay down the yellows first—they're too light to layer on top of darker values.

WET-IN-WET MIXING

I also let colors mix wet-in-wet within each layer by first applying one color, then immediately adding another and allowing them to flow together. This type of layering permits paints to interact. Physically lighter pigments float above heavier ones, some pigments granulate, dyes drift into halos. Subtle, organic textures materialize of their own accord. I cooperate with my paint rather than rigidly control it. Only watercolor permits this wonderful relationship between artist and paint—let it happen.

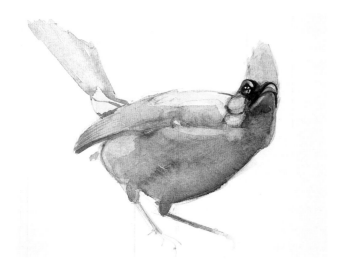

The pigments in the wet-in-wet wash of this cardinal's breast interacted, creating effects I could never duplicate with the rigid control of dryer washes.

WATERCOLOR TECHNIQUES

In this section I'll talk about applying and controlling (or guiding) paint. Only practice will grant you expertise in these areas, but knowing where to put your attention will greatly speed the process.

WASHES

There are two kinds of washes (or glazes). A flat wash is even in tone. Mix your puddle of paint, then use a large brush (No. 10 round or 1-inch flat) to apply it smoothly across and down your paper. Keep your surface flat.

A graded wash is darker on one side and gradually lightens toward the other, or it is made up of different colors blending evenly. Begin with your brush fully loaded with paint. After laying down your first brushful, rinse the brush and load it with somewhat more diluted paint (or paint of a different color), adding this immediately on the edge of the first stroke. Continue this process to the far edge of the wash area.

Gravity is your friend! Use it to allow water and pigment to flow—tilt your board carefully in the desired direction and watch closely, returning it to the upright position when you're satisfied with the effect.

Flat wash.

Graded wash with one color.

Graded wash with more than one color.

MOISTURE BALANCE

Trying to balance moisture can be very frustrating in traditional watercolor methods that allow you only a few layers to get everything right—the reduced number of layers amplifies all errors. Once again, applying many layers makes for smaller mistakes and more opportunities to correct errors.

If your brush is too dry or there isn't enough water in your palette to properly dilute the paint, your brush strokes will be streaky and harsh. You'll probably recognize a dry stroke at once, and can immediately dilute and soften it.

On the other hand, you may pick up too much water with your brush or have too much water in your palette. When faced with a large standing bead or puddle (which could break loose and run or dry oddly), dip the point of your rinsed and blotted brush into the top of the bead and let it soak up the extra water.

If too dry, your brush strokes will appear streaky, labored, and overly textured.

If too wet, a wash will be overly dilute and stand in a puddle.

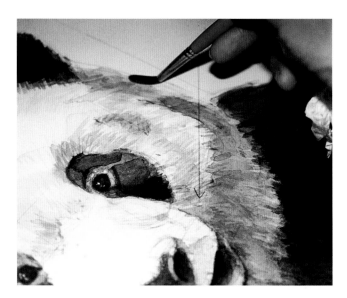

The first brushstroke I applied to this panda was too dry, so I used a clean, wet brush to dilute and soften the area. (See the finished painting on page 44.)

EDGE CONTROL

Edges are essential tools for expressing form (three-dimensionality)—hard edges jump forward and soft ones fall back. They attract and lead the eye whether we want them to or not.

Since sharp edges catch the eye and stop it from moving on, you want more sharp edges around areas of the subject that are coming toward the viewer, and around the painting's focal point where you want the viewer's eye to linger. To create a sharp edge, apply paint to dry paper—it will stay where you put it.

Soft edges imply lack of focus. Use them to describe distant portions of your painting, and in other areas where you don't want your viewer to pause. Soft edges create "gateways" within a painting, allowing the eye to move freely across the page.

Create soft edges by placing your brushstroke onto wet paper, or by applying a wet brush to a hard (but still wet) edge, moistening the paper beyond the edge so that paint can flow gently into clear water. By controlling hard and soft edges, the artist can create strong form and consciously guide the eye of the viewer.

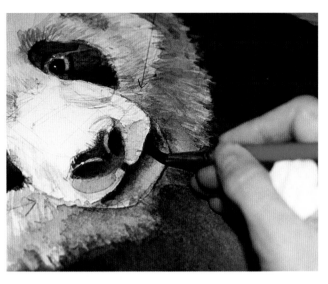

The hard edges around the panda's mouth and nose make that area pop forward.

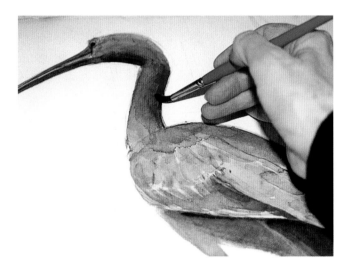

You may want a hard edge on one side of a brush stroke and a soft edge on the other. To achieve this, first lay down your stroke on dry paper. (Finished painting of glossy ibis on page 82.)

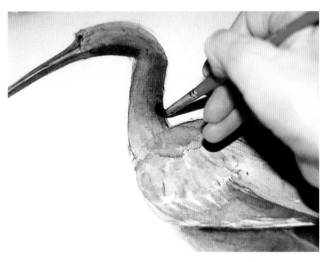

Then immediately rinse your brush, dipping it into your clean water container, and run it down the edge of the stroke that you wish to soften. The still-wet pigment will flow smoothly into the clean water on the paper, tapering off into a soft edge.

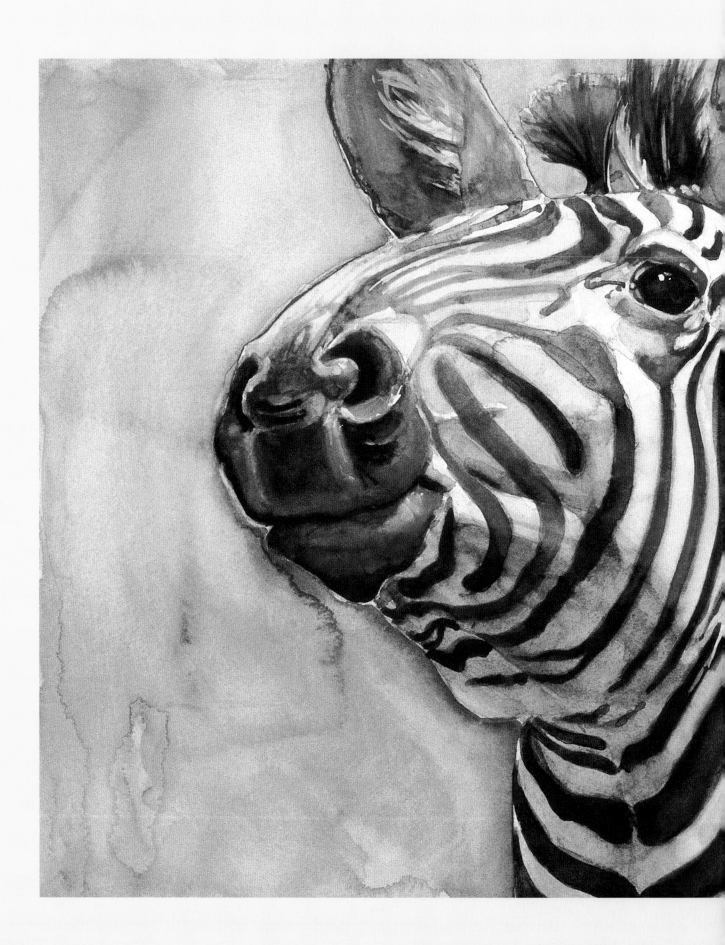

Peggy's No-Fear Painting Process

The last chapter introduced basic watercolor properties and techniques. Only practice will familiarize you with watercolor characteristics. The important thing is to work consciously, paying attention to what works and what doesn't. My method of painting, which I call my "no-fear" process, will help you explore this knowledge painlessly. It is a gentle process with strong results. So relax, and let's paint!

ZEBRA
22 x 30 inches (56 x 76 cm).
Collection of Eunice and James Nondorf.
This zebra struck me first with her expression, then with the endless color possibilities for painting her.

OVERVIEW

I look at watercolor painting as a building process consisting of many decisions. If watercolor is applied in thin layers or glazes, the painting evolves gradually, organically. No single layer has the last word—this is not a three-strikes-and-you're-out procedure.

My no-fear watercolor process is made up of many small decisions (rather than the three or four large decisions of many other watercolor approaches). You don't have to make all correct decisions, just a good percentage—this puts the odds greatly in your favor! There will be a total of approximately ten to twelve layers in your final painting. Like a jetliner on automatic pilot, you're never right on course but always a few degrees off, continually making adjustments.

I mix colors on the paper, not on the palette. Lifting them from their wells one at a time, I clean the brush between colors so as not to contaminate the wells. Color purity is important: You, not the mud on your palette, should make the decisions. It's also important to let each layer dry before applying the next—otherwise the still-damp colors will mix and muddy on the paper.

It's best to begin with transparent colors (see page 65); the light shines through them, and they layer like stained glass. Save opaque pigments for later.

There's never any reason to be tentative: If an area seems too bright, you can always neutralize it later with an overlaying wash.

When the paper is no longer shiny but is still damp to the touch, working further risks unwanted crawl-backs and the mixing and muddying of pigments. Because I roam continuously around my painting, generally the area I start with gets a chance to dry before I return to it.

At a certain point the whole piece is moisture saturated. It's time to let it dry when all areas are too damp to approach safely. If in doubt, let it dry.

After a careful drawing has been made (see Chapter 2, "Drawing"), a painting is usually completed in three basic stages, with several layers in each: initial color impressions; building form, value, and texture; and details and unifying washes. Allow the painting to dry completely after each stage, from a couple of hours to overnight, depending on humidity.

INITIAL COLOR IMPRESSIONS

I begin by staring at my subject and allowing color impressions to emerge. I start painting shadows first because they usually contain more color. I am not committing now—I'm taking that first critical step of putting paint on paper, but in a free, safe way that loosens hand and mind. Nearly everything I do at this stage will be refined and covered up later, so there's no pressure.

This first wash is very wet and loose. It's flat in the sense that it addresses color only, not form. I cover the whole subject at this time. The important thing is to keep the washes light, no more than 5 to 7 percent dark on the gray scale (see "Establishing Values" on page 29).

BUILDING FORM, VALUE, AND TEXTURE

In this stage I begin the process of carving out form and pattern. The layers are still light. Wet brush strokes of color, alternating warm and cool, are laid next to each other and allowed to mingle on dry paper.

Working with different areas of my large image allows drying time between layers in spots where I'm not working at the moment. I create form naturally by building up layers of color. Linear brush strokes begin to define the texture of fur or feathers.

DETAILS AND UNIFYING WASHES

I continue to build form and pattern, but with an eye on pulling the whole piece together. Darker washes solidify value. I add light and dark accents and details, and refine texture. Edges are sharpened and softened to create three-dimensionality, and color temperature (warm and cool) adjusted to evoke a sense of distance. Broad washes integrate disparate areas.

ROCKY MOUNTAIN GOAT
40 x 22 inches (102 x 56 cm).
Collection of Marilynn and Julius Sparacino.
I used to quit too soon when painting animals with this much fur. Allowing more layers (and more drying time) was the secret to a better painting.

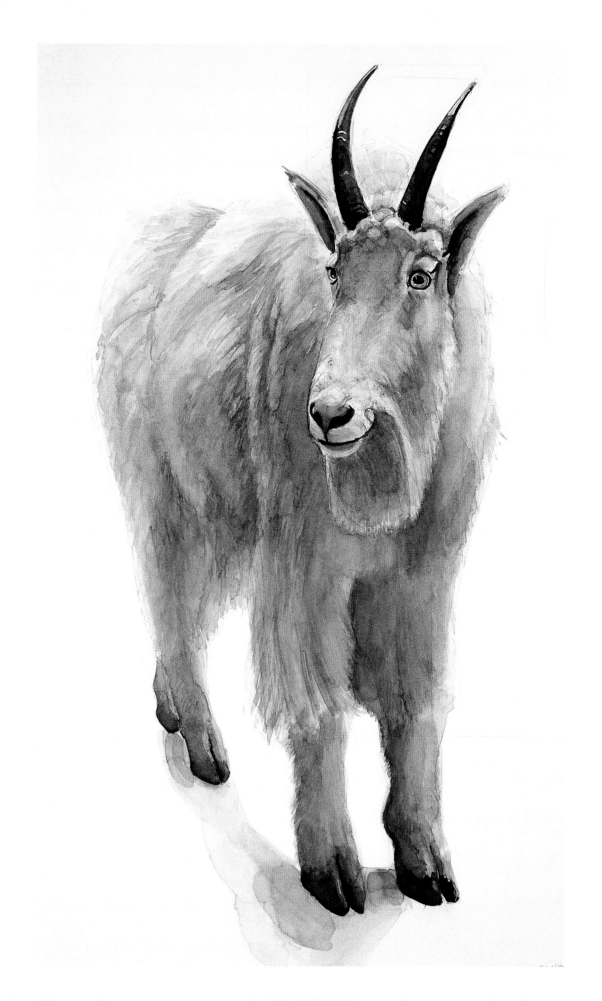

Snowy Owl

The snowy owl is a beautiful and reclusive creature of hush-soft feathers and iron-hard beak and claw. This female wears the barred pattern that camouflages her and her brood from Arctic foxes, wolves, and humans as she defends her nest on the unforgiving Arctic ground. To bring her to life, you need to invoke the softness of her silent flight as well as the fierce competence that allows her to thrive under the harshest conditions on earth. Sharp claws hide beneath downy "boots," but their strength must still be implied.

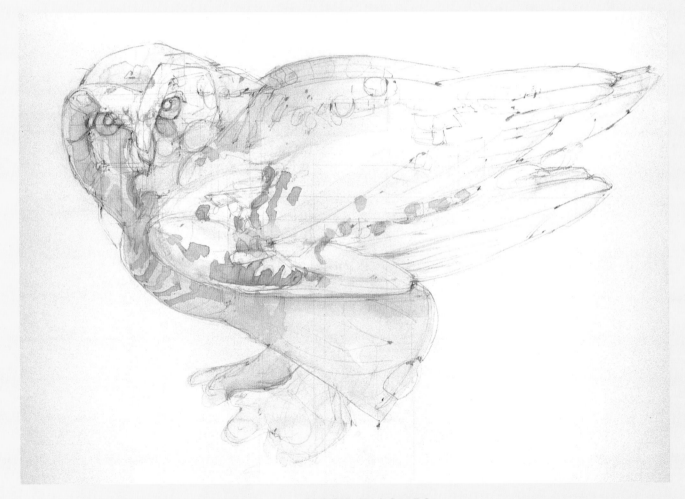

FIRST WASHES

Begin by looking closely at your subject. Lay down your first washes very loosely. There will be plenty of time to refine your painting and add details in later stages. At this stage you are just addressing color; you will build form later. The first wash is very wet and very light. Color choice is almost arbitrary at this point. The second layer begins to establish pattern and is also very light.

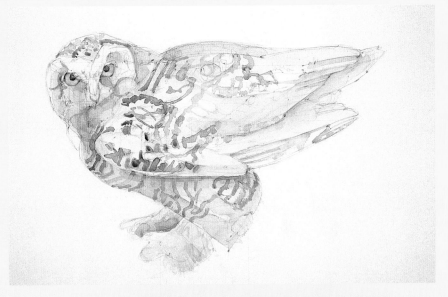

BUILDING COLOR IN SHADOWS

Because the shadows contain the most color, you should begin painting them early on. Form begins to emerge as you build up these layers.

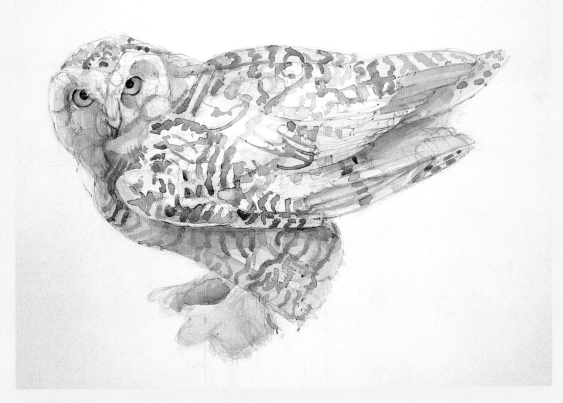

WORKING THE WHOLE PIECE

Make sure the painting is working as a whole. The appearance of any feature is altered by its surroundings, so I don't let myself get stuck in one spot. I constantly move around the painting. From time to time I step back from the piece for greater perspective. I pay increasing attention to my edges—where they are sharp, they appear to come forward; soft edges recede. I begin to develop the eyes and the beak—most of the "sharpness" will be in these features. I am in no hurry, knowing that I'm many layers away from completion.

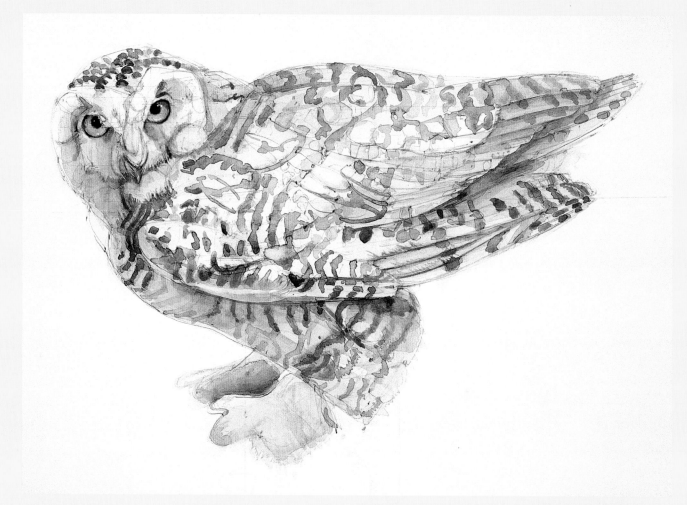

CORRECTING DRAWING PROBLEMS

Recheck your drawing and strengthen values. Darker washes now obscure most of the initial pencil lines. I recheck my drawing (proportions and positions) carefully and make any necessary corrections. This is important! The great strength of this technique lies in the combination of rock-solid drawing and loose, free painting.

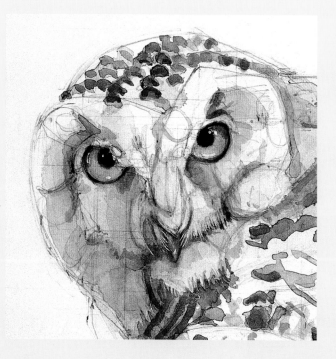

Having corrected the drawing with pencil and paint, I "key" the eyes and the beak (the focal point) with very strong darks, against which I can compare the values in the rest of the painting.

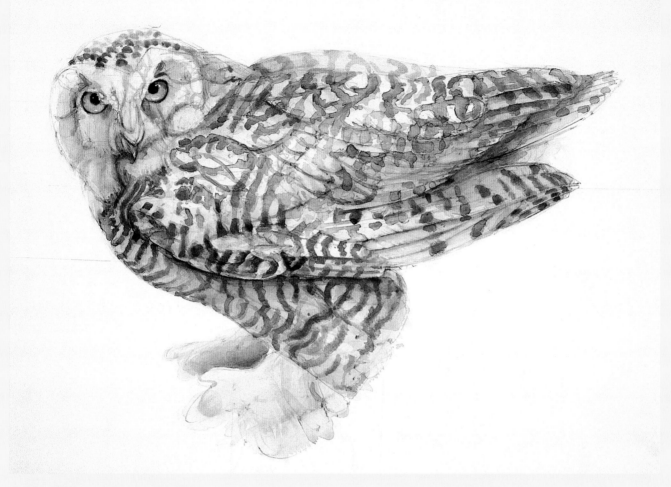

SHARPENING EDGES

Sharpen edges that are closest to the viewer. While I've worked the edges all along, I now look at them with a more critical eye.

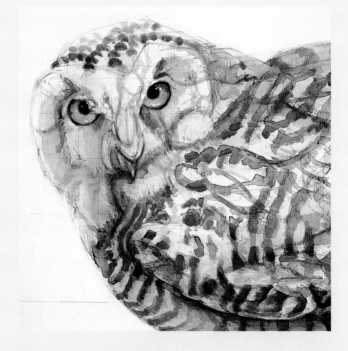

The wing is coming toward me, so I make sure the closest area is sharply defined. I want the "distant" (maybe distant by only an inch or two!) edges of the owl's back to fade away.

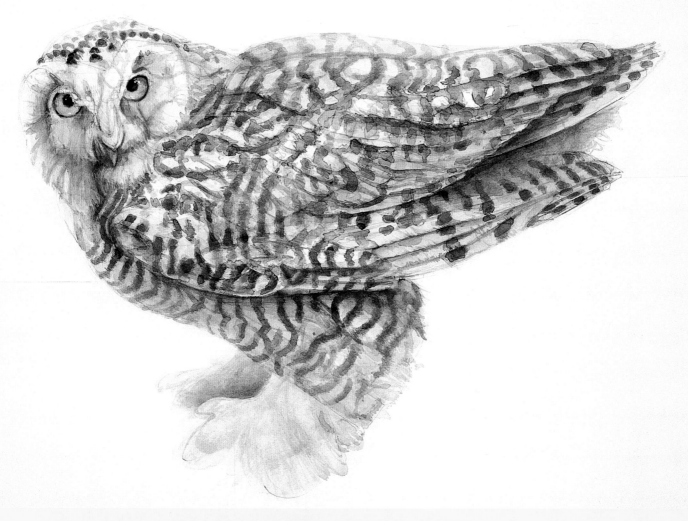

ADJUSTING AND INTEGRATING

Sometimes I need to make corrections to my painting. In this case some lifting was required. I wet the surface to be lifted, scrubbed with my synthetic brush, and blotted with a tissue. Floating a pale manganese blue wash on top pushed the edge back even farther.

WHEN GOOD PAINTINGS GO BAD: CORRECTIONS

It's happened to all of us—we've painted happily all day and put our painting to bed like the cherished offspring it is, pleased with the results. Then, in the cruel light of morning, a glaring error jumps out. It looks disastrous, hopeless. But don't despair too soon—much can be done.

First, make sure that the seemingly offensive area is actually the problem. I've found that often the real problem spot is not the one I've focused on, but an adjacent area. First remeasure carefully. Often the error is in the drawing. If that's the case, redraw—no painting that starts with a bad drawing will succeed.

After verifying drawing accuracy, use your hand to block the suspected trouble spot from your vision. Then cover up adjacent areas, one at a time. Usually when you conceal the real trouble area, the rest of the painting suddenly works— it's as though a piece of a puzzle has fallen into place.

Once you've determined what area you need to correct, there are three major approaches to repairing a painting: integrating washes, applying opaque paint, and lifting paint. I often combine two or more of these techniques in any given correction.

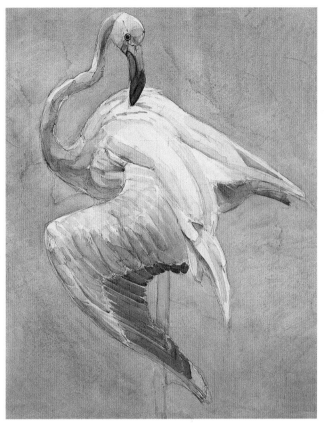

Problem: The flamingo's wing looks separate from the body.

INTEGRATING WASHES

If one part of your painting appears separate and disconnected from the rest, a broad integrating wash is often the answer. "Float" very wet paint onto the paper with a large brush, covering all areas that need to be pulled together. Since the integrating wash will be one of the final layers, use semiopaque or opaque pigments (opaque pigments, thinly applied, will only partially cover the layers beneath). Vary the color temperature, making closer areas warmer.

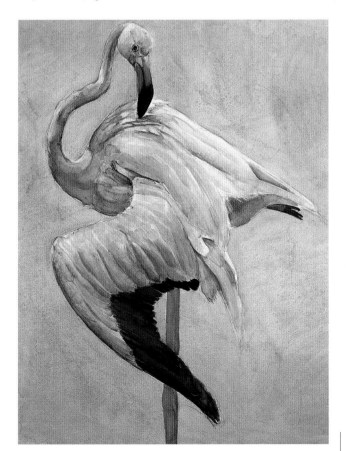

FLAMINGO
30 x 22 inches (76 x 56 cm). Collection of Susan and Patrick Creevy.
Solution: An integrating wash of warm and cool reds (coolest toward the rear, to create a feeling of distance) pulls it all together.

APPLYING OPAQUE PAINT

It's often possible to revitalize a muddy area by applying an opaque pigment, such as cadmium red or manganese blue, or a semiopaque, such as cobalt violet. Again, "float" the paint on in a very wet wash. You can also stroke on dryer opaque pigment; it will have a different look, almost like oil paint.

Occasionally I mix a color with opaque white paint (usually Chinese white watercolor) to cover problem areas. I usually apply these mixes in wet washes that blend virtually undetectably with the rest of the painting. For highlights I use thicker, entirely opaque pigment.

LIFTING PAINT

Sometimes I overwork an area, making it hopelessly muddy. In these cases I simply lift the paint from the area and start over. To do this, first wet the area with a large brush and wait a few seconds for the paint to soften. Then lightly scrub with your brush and dab the paper with a tissue (plain tissue, not the kind with lotion!). Repeat as needed. Allow the area to dry thoroughly before applying more paint.

The 300-lb. paper, because it can withstand a lot of scrubbing, is very forgiving of our mistakes. We should be the same.

WHITE RHINO
40 x 60 inches (102 x 152 cm)
My rhino had become a bit dull and dingy. A broad cobalt violet wash, floated over a muddy area, revitalized him. You can see the glow of the semiopaque cobalt violet on his back.

Problem: I had made the white ibis too dark through overly concentrated layers.

Solution: I first washed away as much color as I could and allowed the piece to dry. Then I applied white gouache (an opaque watercolor) in very thin watery layers to areas I wanted to highlight. I let the layers become more opaque toward the end.

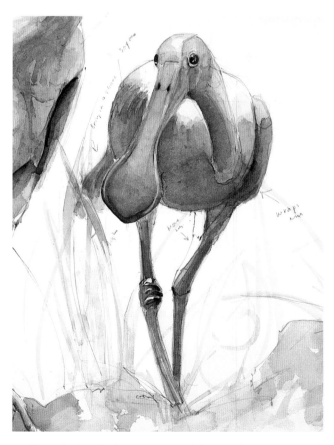

Problem: I had made the roseate spoonbill too dark on the right side of the body. In addition, the tail was too big, and the left leg needed to be moved closer to the right.

Solution: I washed out all that I could and let the piece dry. Then I increased the intensity of the pink color closest to the bill so that the back of the bird would fade out. To correct the tail and leg I redrew them, scrubbed, and then applied thin layers of white gouache to cover up the "ghost" of paint that wouldn't lift. After the many white layers dried, I repainted the leg and extended the background over the new white paint, up to the bird.

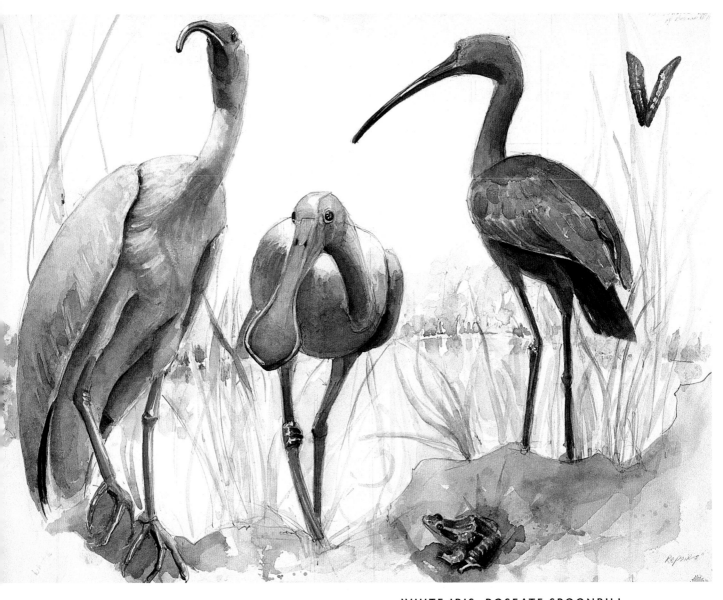

**WHITE IBIS, ROSEATE SPOONBILL,
AND GLOSSY IBIS**
22 x 30 inches (56 x 76 cm)

FINISHING A PAINTING

Your painting is light, bright, and pretty at this point. It is pleasant, but lacks the solidity and backbone of strong values. It's as though you've been dating—making nice, no fights yet. Now it's time to get married, to recognize and solve problems, to achieve something deep and satisfying. Don't let fear of commitment block your way to a strong painting! As you progress, there may be a stage in which you feel you have lost the beautiful color without having reached solidity. Keep going! This is part of the process—instill strength, then work it through to combine power and beauty in the end.

Finishing a painting involves much more than simply adding final detail and going darker: the whole piece must be pulled together. At this point, I stare more at the painting than at the subject. The piece tells me what to do next. If nothing specific jumps out, I begin by exaggerating form. There are several elements to address.

Contrast and edges are essential to achieve three-dimensionality. Remember, the eye naturally travels to where the lightest light meets the darkest dark with the sharpest edge and the most intense warm color.

A lot of sharpening goes on at the finish. I allow several layers to achieve the effect I want.

I want to make sure the viewer's eye is guided in the way I intend—this is usually a matter of edge control. Hard edges stop the eye; soft ones permit the eye to move on. A good painting contains a combination of sharp stops and soft "gateways" (ushering the eye along), each in the right places.

Often, one area will look separate from the rest. A broad integrating wash pulls everything together. I use a neutralizing complementary wash if an area seems too bright, or a dark wash of analogous colors to bring a too-light area into line with the whole.

When you feel close to finishing, it's time to seek out other perspectives. Turn the piece upside down; hold it up to a mirror. This allows you to see the design elements as distinct from the subject. If the painting still works, great. If it doesn't, rethink and adjust.

In the end, there's nothing like a fresh eye to make a final evaluation. I have trusted friends I can count on to tell me, "Nope, keep going," (when I'm eager to get on to the next project) or "For goodness sake, stop!" (when I'm laboring to add that umpteenth detail). These people are invaluable, and they don't have to be experts. I used to pay my kids a dollar for an immediate response; what came off the top of their heads usually helped.

Putting the painting aside for a week or two freshens my own eye. When I see my work after a break, often something jumps out, begging to be changed. Final adjustments constitute a small but very important percentage of the paint on your paper. They make the difference between a good painting and a great painting. Be critical now, and be happy for a long time afterward!

Remember that not all paintings are supposed to work. Do all you can, learn, and move on to the next piece. Try to remember that you will learn more from your mistakes than from your successes. When a baseball player hits one in three, he's considered a good hitter.

It's important to work often enough that you won't feel that each painting is too precious. It's easier to let go when you know that you will paint again tomorrow or the next day. Don't take failures personally. If a painting isn't working, this is often as it should be.

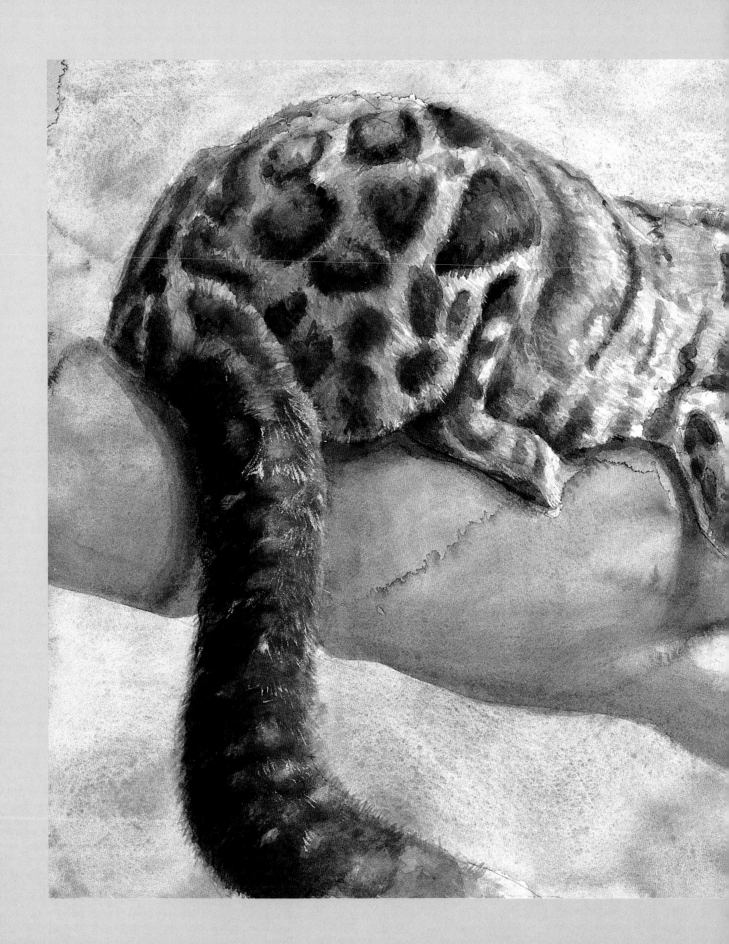

Pattern

Artists and nature both use pattern, but usually for opposite reasons. Artists employ pattern to attract the eye, to intrigue and mesmerize. Nature's patterns, on the other hand, often evolved to confuse the eye, to disguise and mislead for the survival of the species. A cheetah's spots, a penguin's white belly, and a tiger's stripes are all designed to interfere with the appearance of form. Artwork needs dimensionality to be perceived as solid and real, but most animals benefit from appearing flat and fading into the background. Don't be fooled by nature's disguises—form is of ultimate importance. Build form and pattern together, and watch your beautiful subject come to solid, three-dimensional life.

CLOUDED LEOPARD
22 x 30 inches (56 x 76 cm). Private collection.
To paint the leopard's spots convincingly, I needed to show the pattern as part of the form—in other words, spots in the lighter areas are themselves lighter, and spots in shadow are darker and somewhat softer.

COUNTERSHADING

Nature's most ubiquitous scheme of misdirection is a subtle pattern called countershading, in which an animal's pigmentation is lighter underneath than on top. It is common in all the varied corners of the animal world. Look at the light underbellies of lions, mice, sharks, and bullfrogs for examples of countershading.

The animal's underbelly, normally darkened by the shadow of its form, remains light. To understand this, look at the shadow on the underside of your arm in a good light, then imagine the effect if the underside of your arm were painted white. Countershading has a flattening effect, good for hiding but bad for art!

An aquatic animal benefits doubly from countershading, because when seen from above its dark back blends with the water, and when seen from below its light belly blends with the sky.

Address the problem of countershading by using what you know about color and reflected light. The underbelly of many animals is more lightly pigmented in precisely the areas where you would like to put the darkest shadow. Here let color temperature define form—model the animal's shadow contours in cool neutral blues, greens, and violets that naturally recede from the warmer tones of its upper body. You will also let the color of the surroundings reflect onto the underbelly, cooling as it recedes.

DIBITAG
60 x 23 inches (152 x 58 cm).
Collection of Mary Anne Rogers and William Stanley.
See how this antelope's "white" underbelly reflects the red-browns of the Kenyan soil and then cools in hue at its farthest edges.

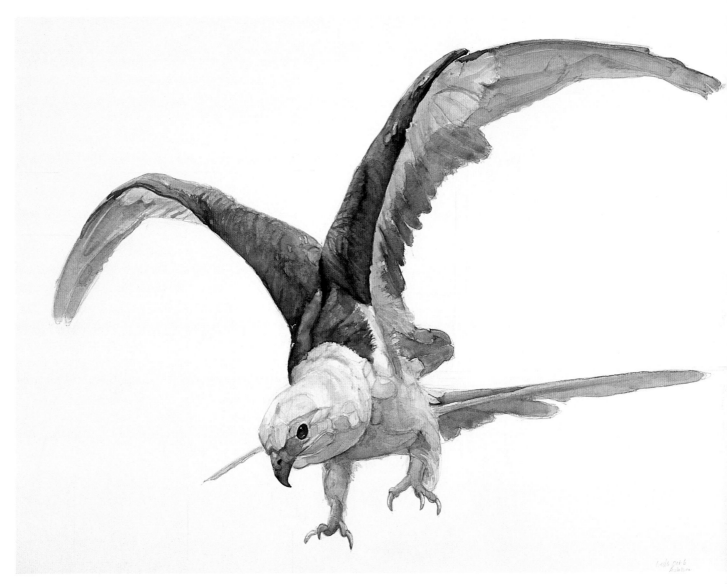

SWALLOW-TAILED KITE

22 x 30 inches (56 x 76 cm). Collection of Patricia and Les Russo.
*The white underside of this kite helps her blend into the sky and
be less visible to prey animals below. My challenge was to paint the
shadows dark enough to convey solid form, but still have them
appear white to the viewer. To accomplish this I layered lots of cool
blue-greens into the shadow areas, while painting the light area of
the white head in primarily warm colors.*

SPOTS AND STRIPES

Spots and stripes also thwart the perception of form. A leopard's spots break up the three-dimensional appearance of his body so that it blends into the dappled leaves of his tree-lair. A tiger's stripes fragment her solidness and realign it with the vertical vegetation of her jungle habitat.

Our challenge is to paint a patterned animal or object accurately, but without allowing nature's sleight of hand to flatten our subject. The answer is to develop form and pattern together.

Many beginners make the mistake of painting a subject without its pattern, then plunking down the spots like chocolate chips on a cookie—all in the same tone, from the same brushload of paint. Pattern applied this way looks stuck-on and artificial. Instead, develop pattern and form together, building each slowly. Remember that pattern lies on the surface, and will incur the same tonal changes as the form underneath. To help build form and pattern together, spend three minutes developing form; when that paint dries, spend three minutes building washes that describe the pattern. Let form dominate.

Art is about communicating your own vision, your personal response to your subject. You'll want to paint a duck, not merely describe it technically. You have choices about what you have to say with brush and paint. In your painting you can hint with minimum detail that your subject has this or that pattern, without destroying its form.

Duck eggs painted incorrectly (top) and correctly (bottom).
When my students illustrate duck eggs, they usually manage to obtain a good sense of volume until they apply the dripping Jackson Pollock–like spots that cover them. The spots on the top of the egg where the light is brightest should be lighter than the spots in the shadows below.

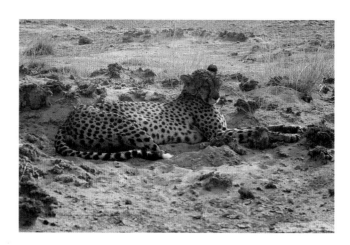

A cheetah's spots break up the appearance of form, allowing her to blend into the rocky, sandy fabric of the African savannah.

TIGER

22 x 30 inches (56 x 76 cm). Collection of Marilynn and Julius Sparacino.
To me, the tiger's extraordinary eyes evoke her solitary, secretive life, her stripes the deep forest habitat. Dense vegetation favors neither huge herds of hoofed prey animals nor pack hunters, so this largest of living cats hunts alone. The female fends for her cubs by herself, as the male is only a quick-passing visitor.

Radiated Tortoise

The radiated tortoise is a slow, deliberate, peaceful crea-
ture that evolved with few enemies on beautiful and re-
mote Madagascar. I think this shows in his proud but
guileless bearing. There is a wonderful sense of eternity
in his slow movements and serene eyes.

Reptiles show two different types of pattern: pig-
mentation, or coloration, and scale pattern, the arrange-
ment of scales on the body or shell. Once again, build
pattern and form together.

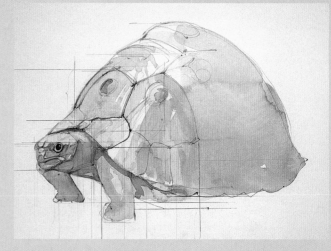

INITIAL WASHES

*I draw the scale and pigment patterns carefully. After the first light
wash, I squint and begin to build darker areas of both form and
pattern, alternating between the two.*

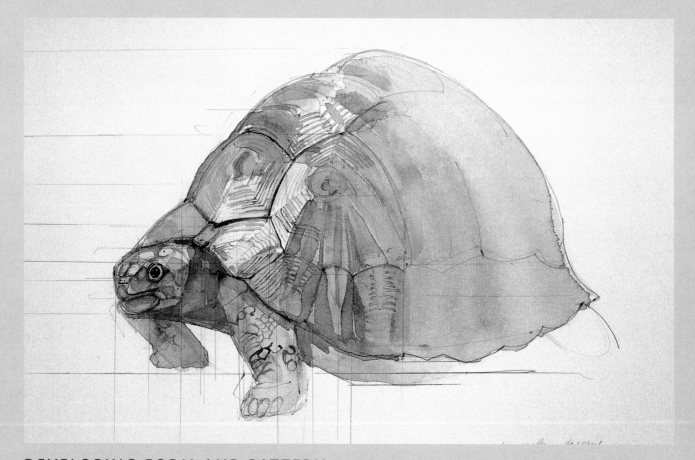

DEVELOPING FORM AND PATTERN

*I begin to differentiate clearly between the light and shadow portions of the shell,
always watching the balance of warm and cool color. Pattern and form emerge together.*

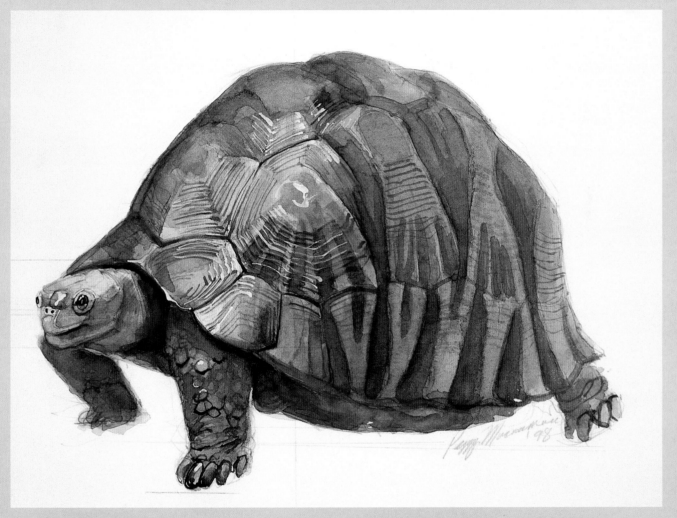

FINAL WASHES

Many layers build strong form that contains the bright and distinct pattern, making the finished painting cohesive. The warm red-browns in the closest, most convex portion of the shell pull that area forward. Notice how the more developed pattern in the nearer portions of the shell attracts the eye, allowing less developed, more distant portions to fall back.

RADIATED TORTOISE

15 x 22 inches (38 x 56 cm).
Collection of Kathleen and John Gawlick.

Zebra

A zebra's stripes serve as camouflage, but when she is away from camouflaging vegetation, her stripes actually enhance form as they curve around and exaggerate the body's contours. Your hardest job in painting the zebra is to keep the pattern attached to the body (not visually jumping away as in the poorly painted eggs on page 88).

Lots of layers will tie all the colors together and soften the edges of the pattern. Be sure that the value of the pattern corresponds with the value of the form—in other words, the stripes are lightest where the body is lightest, and darkest where the body is darkest.

LIGHT WASHES AND "KEYING"

In the first few washes I lay in the stripes, along with the beginnings of form, in a very light and colorful way.

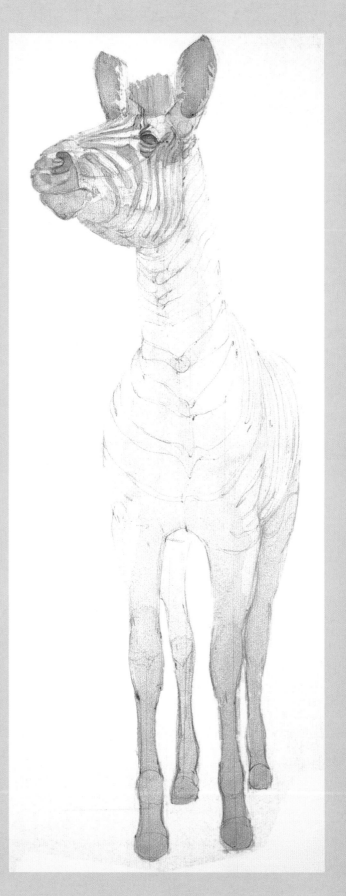

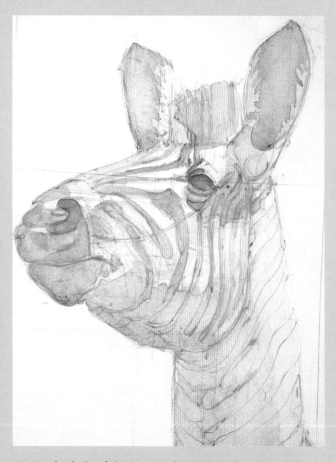

I paint the darks of the eyes in order to "key" the values of the painting, establishing a benchmark value next to which I can judge all other values to follow.

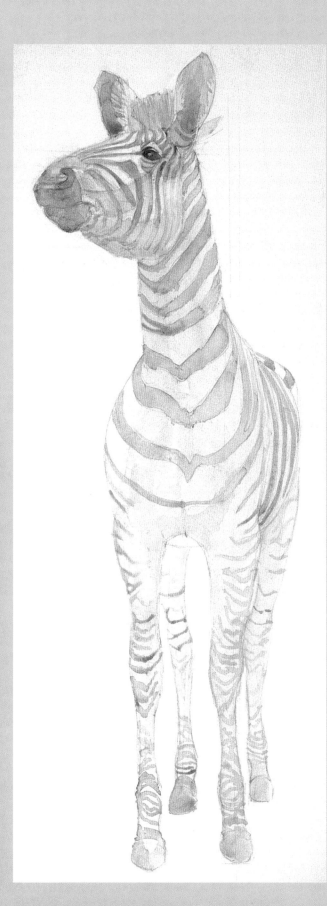

BUILDING PATTERN AND FORM

I build pattern and form together gradually. The stripes will be very dark, so to ensure interesting variation in the stripes, I apply layers of many different colors.

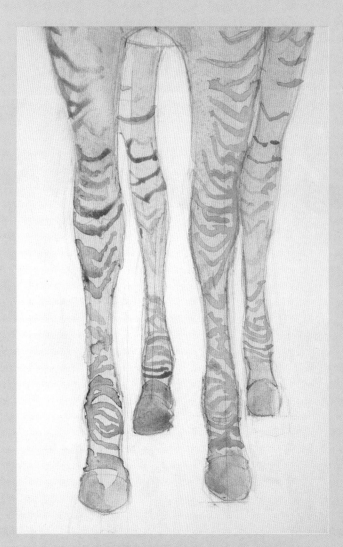

I also strengthen the edges and values that are coming forward. The rear legs will stay in nearly their present state, with the pattern light and loosely defined.

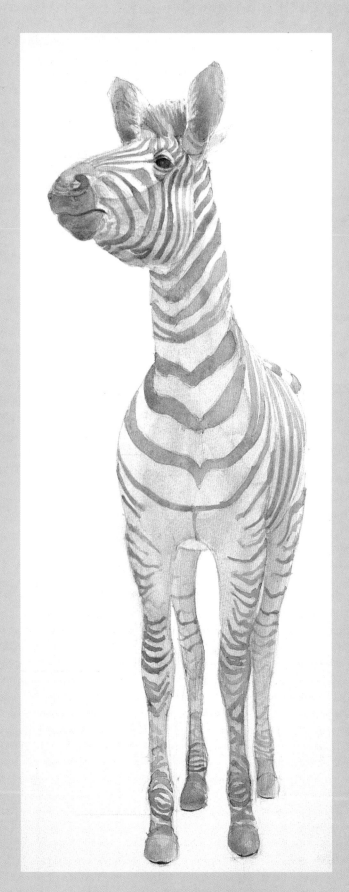

SOLIDIFYING VALUES

I continue to build form and pattern, but with an eye toward pulling the whole piece together. Darker washes solidify value. I add light and dark accents and details, and refine texture. Edges are sharpened and softened to create three-dimensionality, and color temperature (warms and cools) is adjusted to evoke a sense of distance. Broad washes integrate disparate areas.

BUILDING SELECTIVE VALUES

I give lots of attention to selective values at this stage.

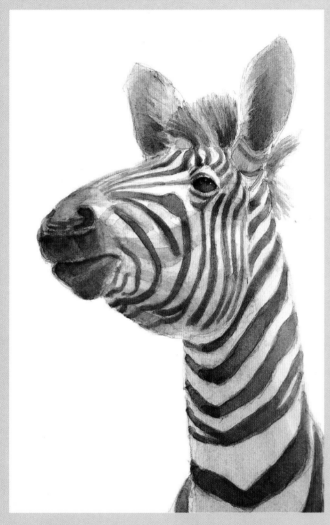

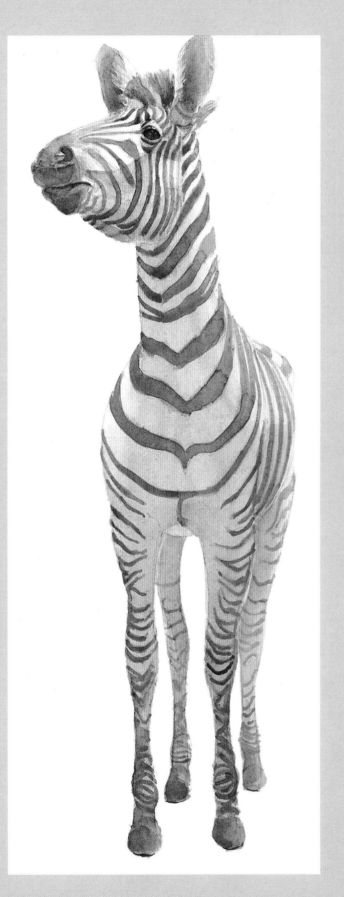

By strengthening values in certain areas of the painting I can call more attention to them. In particular I strengthen the values of the muzzle, which will help to bring it forward.

INTEGRATING WASHES

The chest area was still a bit flat and dull, so I finished with a warm integrating wash that adds both rich color and tone.

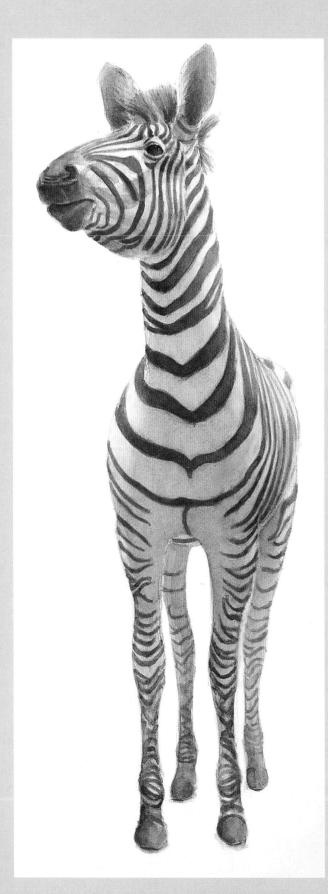

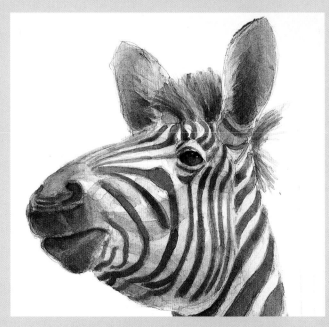

Dark accents in the ears and nostrils and around the muzzle strengthen their impact.

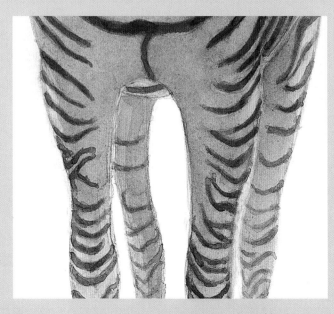

The warm integrating wash contrasts nicely with the blue hues in the flank and rear legs, allowing distant areas to fall back.

ZEBRA
30 by 12 inches (76 by 30 cm)

TOTAL CAMOUFLAGE

In straight-out camouflage, an animal's pattern and coloration mimic its background to the greatest degree possible. The intricately camouflaged tend to be slow-moving creatures such as bark moths and Sargasso fish that vanish into the plants that define their restricted world.

A painting that is purely a study of camouflage rarely succeeds—you may want to allow the animal to stand out in some way. You can do this by eliminating part of the background, or by using strong directional lighting to subtly lift an animal out of hiding.

MADAGASCAR CHAMELEONS
15 x 30 inches (38 x 76 cm)
With icons of camouflage like chameleons, you can show off their pattern while maintaining their essentially hidden character. You do this by emphasizing the facial features and selectively limiting the background around them.

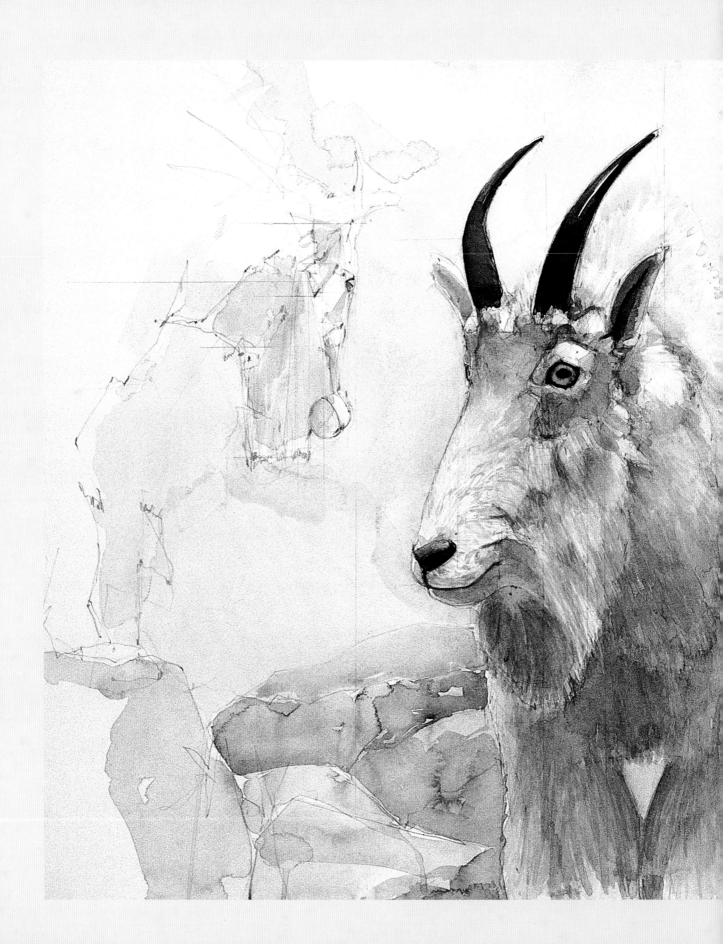

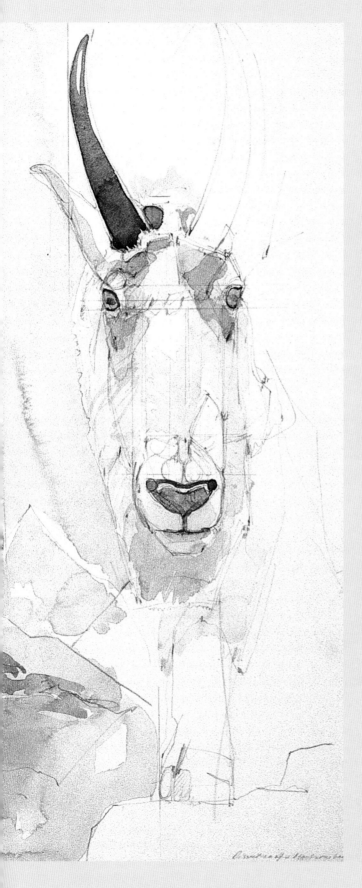

Fur

When painting mammals, nothing will increase the vitality of your work more than effectively depicting the rich texture of fur. The sensuous depth of thick fur harbors mysterious shadows and invites your viewers' fingers to dive in and explore.

My many-layered approach is perfect for building depth. The technique is not complicated, but it takes slow, repetitious actions. It may seem as though you're not getting anywhere because you're always waiting for layers to dry. But building fur is almost a sure thing (and this makes for a nice change!), so think of it as a slow relaxation exercise.

ROCKY MOUNTAIN GOATS
22 x 30 inches (56 x 76 cm). Courtesy of Aron Packer Gallery.
Many layers of different colors carefully follow the direction of the fur pattern. There's little actual white showing in the bristly coats of these mountain goats.

BUILDING TEXTURE

For best results, approach texture the same way you do pattern, working with texture and with form at the same time rather than trying to add texture at the end. Squint and lay in large areas of color, then work in some texture, then apply another general wash, and so on.

Fur doesn't just hang uniformly, but follows a distinct and beautiful growth pattern—the shorter the fur, the more pronounced the pattern. As you begin your slow looking, study the arrangement of the fur. See how it swirls in a vortex on the chest, belly, and rear, and raises in a ruff around the neck and shoulders. Try to render these areas accurately, checking your drawing constantly as you paint.

Squint and pick out areas of dramatic light and dark, Get into these areas and layer shadows under clumps of fur. Look for specific arrangements in the fur, and render them accurately.

With each successive layer of fur, use more pigment and less water, but remember that there are often areas in a painting that require large, wet, integrating washes up to the very end.

I left the distant area of the bison's side in its early state of a few light washes, allowing the flank to recede. You can see in this detail how form is already defined. Once the first wash was dry, I laid in some darks with a jagged motion suggesting fur.

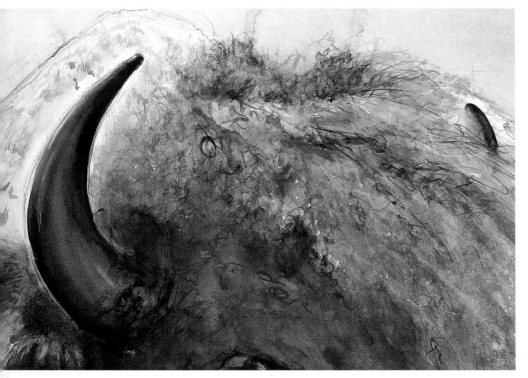

In final layers I use mostly pigment. The crispness of the individual hairs is convincing only because the lines lie over so many previous layers of color. I used white gouache for the highlight on the horn.

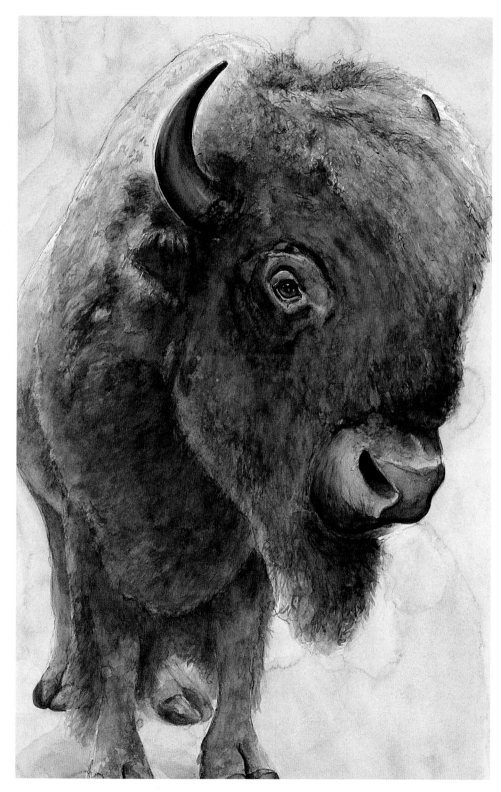

AMERICAN BISON
60 x 40 inches (152 x 102 cm)
The bison's coat is shaggy, almost woolly–very dense with little gloss. The fur is a bit messy–painting it with too much tidiness would reduce the impact. Even this shaggy fur has a subtle directional pattern.

Black Bear

The black bear's thick, dark coat is ideal for deep color layering. Because it is so dark, there's little need to worry about losing light areas by using plenty of strong color. The thick fur of the black bear needs at least a dozen layers.

You'll introduce fur texture in the very beginning, applying a very wet wash with rhythmic, jaggy strokes. Though much of the initial texture may disappear into subsequent form washes, subtle bits of it will remain. In some areas, with each successive layer your pigment becomes more intense. Use a dryer palette for later layers. The final layers are mostly pigment.

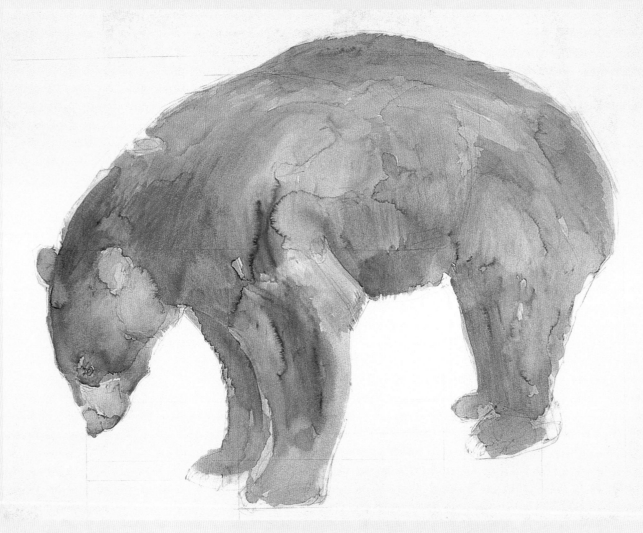

FIRST WET WASH
I paint the first wash with jaggy strokes and lots of wet color.

BEGINNING TO CARVE
FORM AND FUR PATTERN

I begin to layer with my large round brush (No. 10 Crayola) and the same rhythmic strokes, carving out form and paying very close attention to the fur pattern. Don't try to fake fur detail! By the end of this stage I'm occasionally using the smaller brush. The wash application is still very wet.

ALTERNATING TEXTURE
WITH FORM WASHES

I increasingly use the smaller round brush (No. 8 United), with more precise strokes. I place shadows as accurately as the eyes and nose. I squint for form often, and add form washes with the large brush in between texture applications. It's important to keep the whole painting going at once. I keep a tissue handy for wiping larger areas in case I get too dark in places.

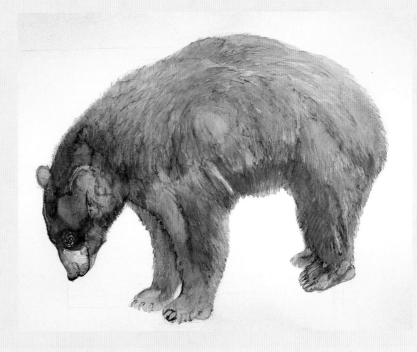

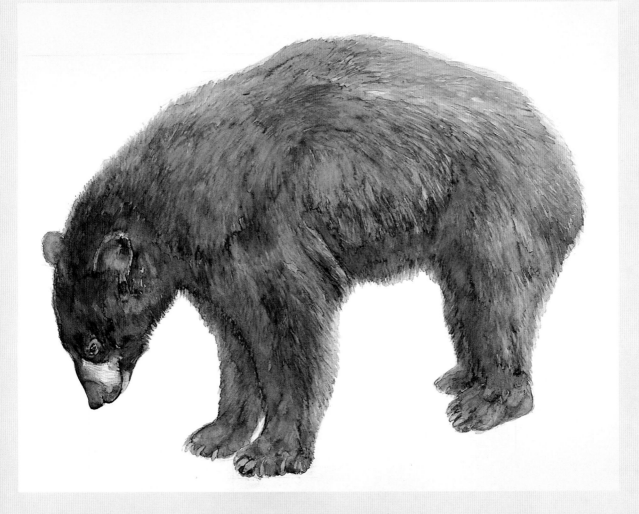

FINAL WASHES

Slow down and look for your darks. The pigment is more concentrated, the palette drier. Alternate between small-brush textural detailing and large integrating washes (which will still be quite wet and not so concentrated). Final details are painted with almost pure pigment.

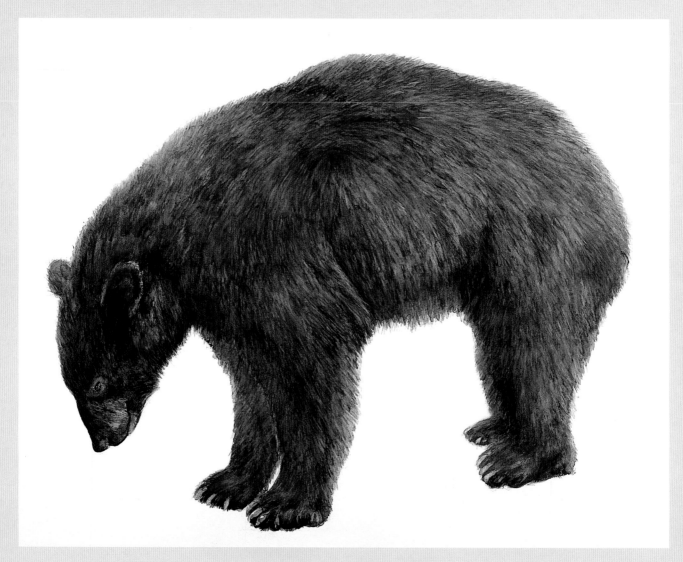

BLACK BEAR
40 x 60 inches (102 x 152 cm). Private collection.

Gray Fox

Our native gray fox is a sleek and swift predator that makes its home in wooded and brushy areas. The gray fox is the only member of the dog family that can climb trees, which it does to find shelter or hunt for birds.

The gray fox's fur has a subtle but beautiful color pattern. The fur is grizzly gray on top and rusty red along the sides with a striking white throat. The pattern of the shorter fur is quite apparent and adds to the figure's sense of motion as the fur sweeps and turns

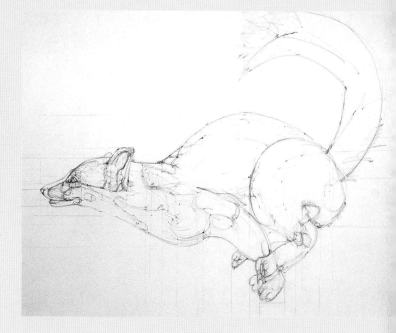

DRAWING
Begin with a careful drawing to establish proportions.

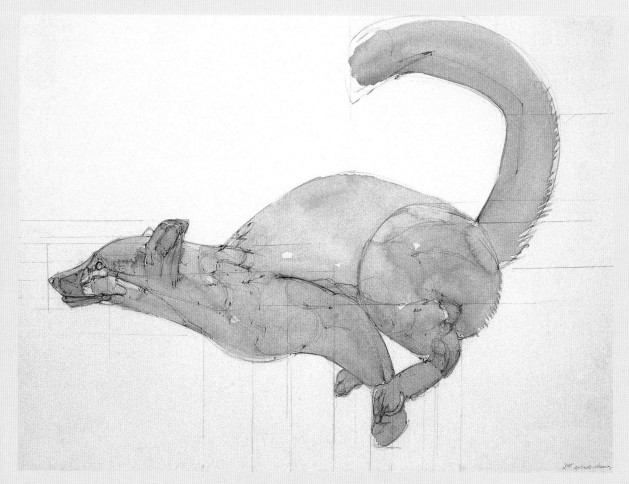

FIRST WASH
Notice how I incorporate some jaggy fur texture on the tail and rump even in the first wash.

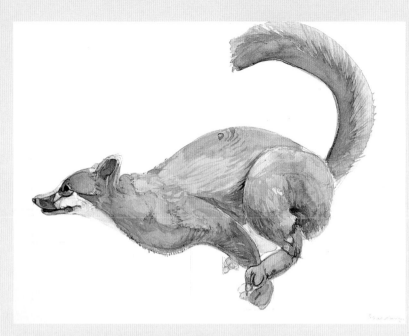

FIRST LAYERS OF FUR

Though there is no detail at this stage, I broadly but clearly spell out the fur's directional sweeps.

MORE LAYERS, FUR PATTERN EMERGING

With more layers and some detail the overall look is still fairly rough, but I've clearly established the underlying structure of the pelage.

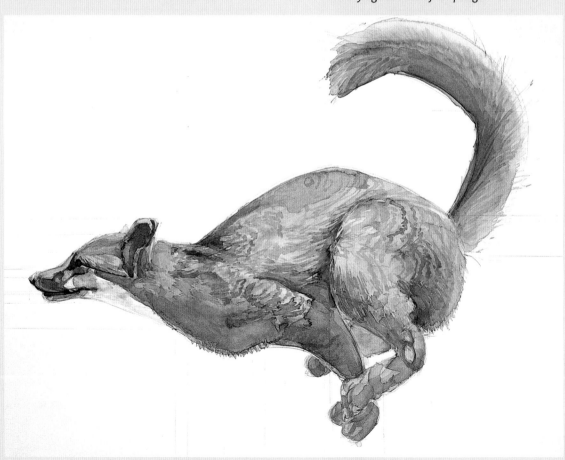

FINE DETAILS

More layers of neutralizing color and ever more refined detail pull the painting together. If I had attempted this fine detail without the initial structuring, the results would have been lifeless and unsatisfying.

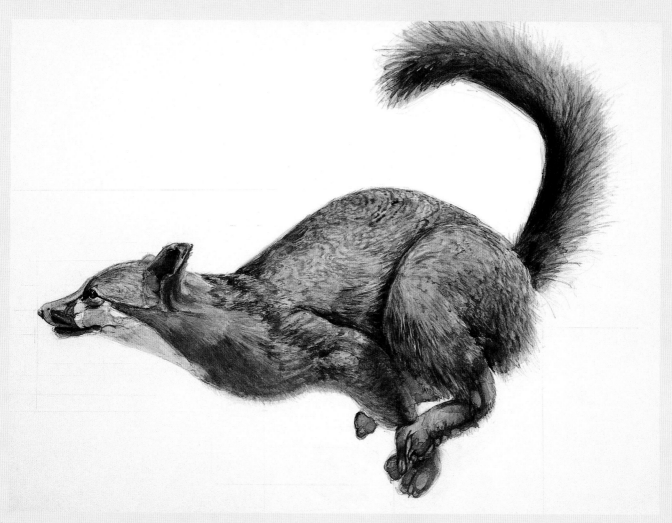

GRAY FOX
22 x 30 inches (56 x 76 cm)

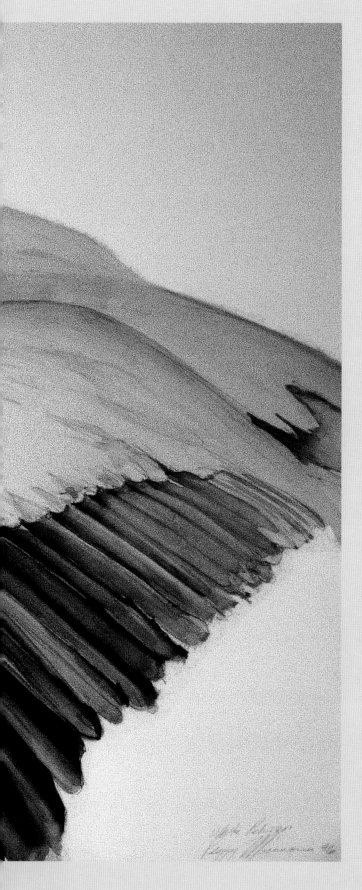

Feathers

Feathers are most familiar to us as tools of flight. But many scientists now think that feathers evolved as insulation on dinosuars, who passed them on to their descendants, the birds. Perhaps this helps explain the variety of plumage, from a gull's efficient flight feathers, to the ostrich's fluff, to the peacock's glorious tail plumes.

The wings and tail of a bird are engineering marvels that permit flight, and it's important to learn enough anatomy to keep your subjects airborn. You'll learn to paint typical feathers, such as the pelican's, almost sculpturally, showing each feather as a facet that reflects light. On the other hand, you'll paint the flightless ostrich's plumage almost as you would fur, with many textured layers.

WHITE PELICAN
22 x 30 inches (56 x 76 cm).
Collection of Elizabeth and Fred Ockwell.
Feathers are wonderful instruments of flight and protection.
It's well worth the effort to learn to paint them well.

FEATHER GROUPS

Feathers keep a bird warm as well as allowing it to fly. This means that feathers differ in structure and texture, depending on function and location.

A little knowledge of anatomy is very helpful—as Leonardo said, "To know is to see." Look closely at a typical bird and see how the plumage is arranged in distinct groupings called tracts. Within each group, feathers grow in orderly, overlapping rows. The feathers in each tract have similar function and structure. There are four main feather groups we'll concern ourselves with: the primary flight feathers, the secondary flight feathers, the wing coverts (small, covering feathers) and back feathers, and the tail feathers and tail coverts. This knowledge will help you draw the bird. Working from general to specific, sketch in the larger shapes of these feather groups before moving on to draw individual feathers. Notice how the patterns of the plumage follow the contours of the feather groups.

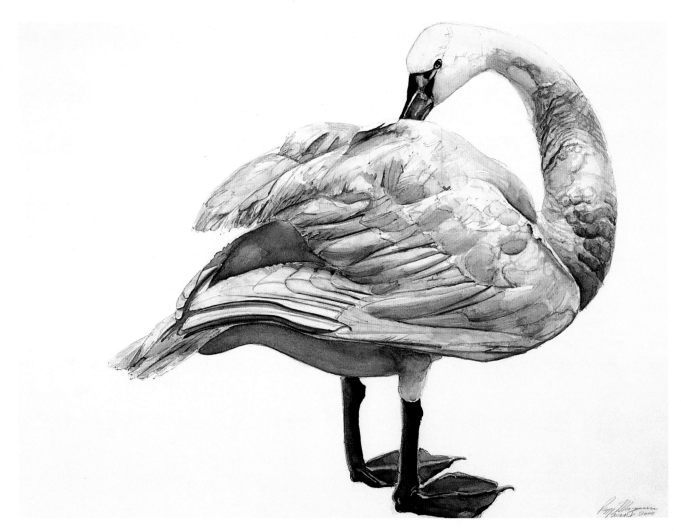

TUNDRA SWAN
30 x 40 inches (76 x 102 cm). Elizabeth Margaret Halleron.
The swan is a good example of a strong flying bird with prominent feather tracts. Notice that form defines most feathers as well as the bird's body. I limit the rendering of linear texture and place it carefully to avoid busyness. Too much linear texture makes the bird look shabby and unhealthy. As this swan preens, she lifts each feather tract to put it in order.

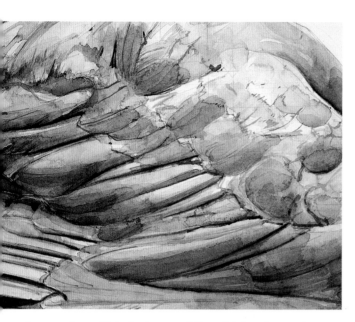

Locate primary flight feathers carefully and define them with shadow description.

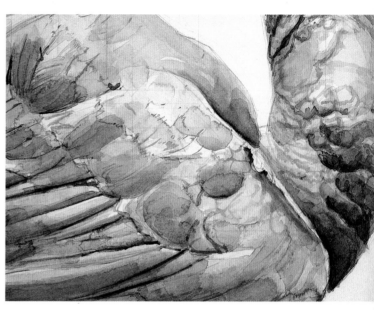

Add the secondaries and give them form with reflected light (light reflecting from other surfaces back into shadow areas).

The wing coverts and back of the swan consist of soft rounded feathers. Create softness by overlapping layers of color, minimizing crisp edges. Define only those edges you see when you squint.

The uppertail coverts (small, soft feathers that cover the base of the tail feathers) had lots of jagged edges that the swan hadn't preened out yet. Because this edge is close to the viewer, I textured the feathers with crisp linear strokes after the form had been established.

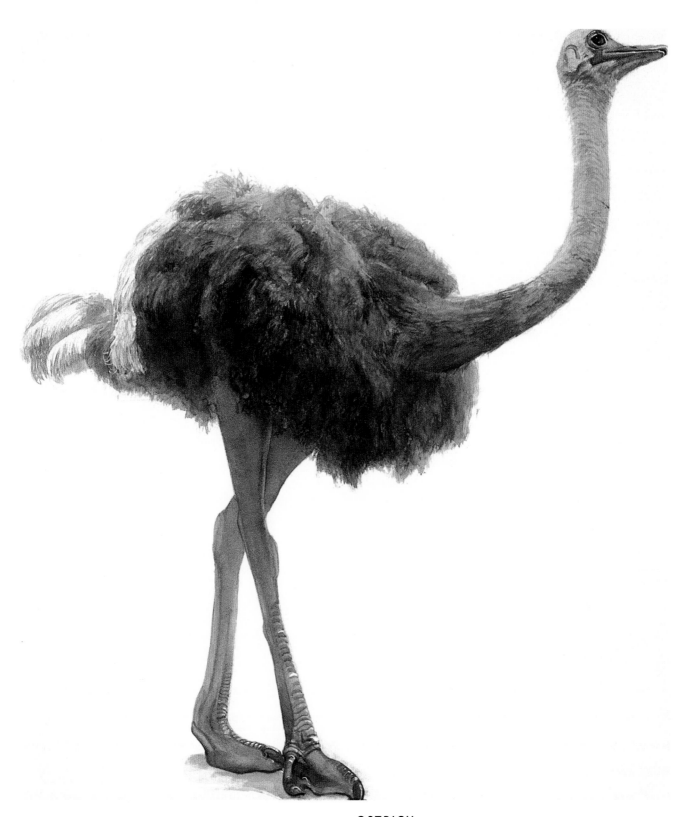

OSTRICH
40 x 35 inches (102 x 91 cm)
The flightless ostrich's soft plumage appears fluffy, almost furry.

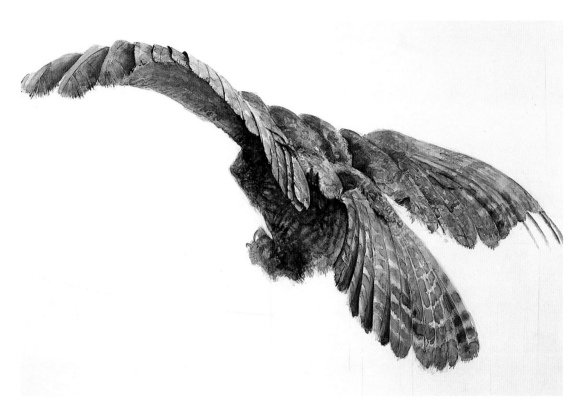

GREAT GRAY OWL

30 x 40 inches (76 x 102 cm)
An owl's sleek flight feathers appear almost sculptural, while its downy breast conveys ultimate softness.

BALD EAGLE

30 x 40 inches (76 x 102 cm)
More detail doesn't necessarily make a good painting, but correct and pertinent detail does. There was lots of fussy pattern on the back of this immature bald eagle, but because I wanted this area of the painting to fade into the distance, I just suggested the pattern, leaving it soft and unformed. The wing comes toward the viewer, so I sharpened the detail of the pattern on the closest portion as well as on the head.

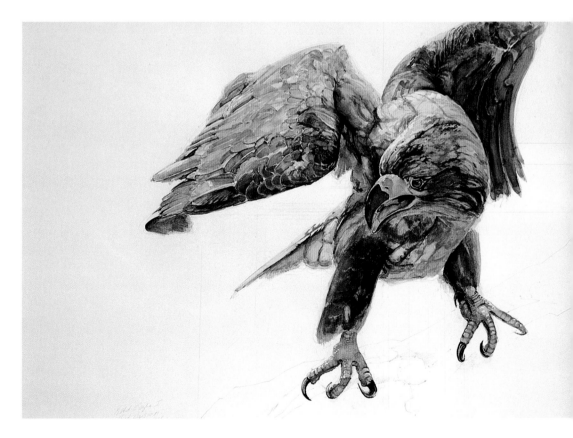

Turquoise-fronted Parrot

With their bright feathers, charmingly eccentric person-alities, and remarkable imitation of human speech, par-rots have long fascinated humans. The parrots I've seen in their native habitat are wild, free creatures in churning, chattering flocks, their brilliant primary colors flashing within lush green tropical forest. It's heartbreaking that the pet trade snares huge numbers of parrots every year, and that many of these die in transit.

INITIAL WASHES

During the first wash, paint in the general color of each feather, then add a swath of clean water down the center of the feather with a wet brush. Next dry your brush and lift the water, leaving a thin line of pigment at the edge of each feather. If the edge needs to be softer, let the layers overlap or soften the edge with plain water.

The feathers that seem to be fading away can be left without further detail. You'll carve out others that need to be more promi-nent in subsequent layers.

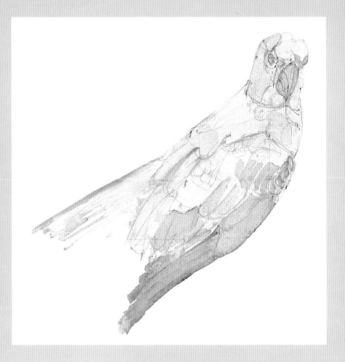

SCULPTING FEATHERS

As you add layers, leave some of the feather shafts light. Approach a bird painting somewhat as you would a sculpture, thinking of each feather as a separate facet that catches light.

Particularly watch for the primary flight feathers—there are usually between nine and twelve. If you are painting accurately, you need to count them. The number of secondary flight and tail feathers is also important.

Other than these large feathers, delineate individual feathers only as needed. Even in the case of flight and tail feathers, be discriminating—perhaps only part of a feather will show clearly. My general rule is that if you don't pick up clear feather separations when you squint at the bird, they don't need to be in the painting. Once again, texture should defer to form, though you'll work on both at once.

FINAL LAYERS

Final layers add subtle color blends and dimension. Make sure the
beak has plenty of contrast to make it look hard and shiny.
(See "Beaks" on page 126 for more information on painting beaks.)

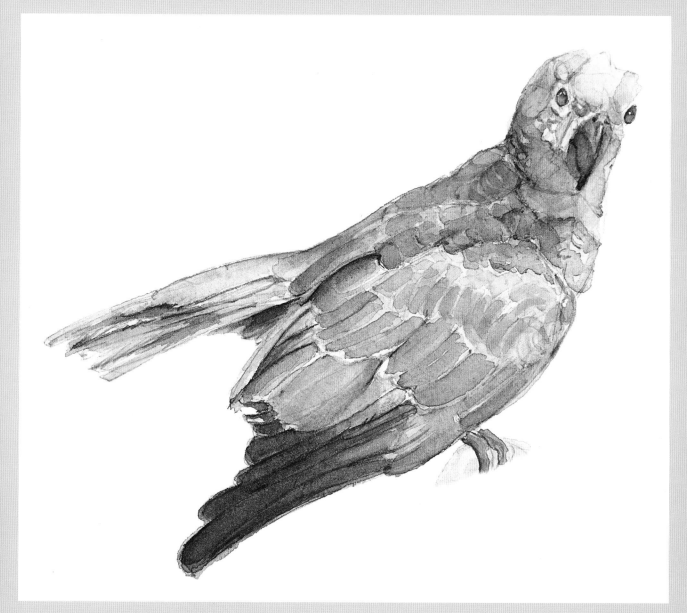

TURQUOISE-FRONTED PARROT
8 x 10 inches (20 x 25 cm)

Scarlet Ibis

The scarlet ibis is native to tropical regions and rain forests of Central and South America. Its striking red plumage comes from pigments in the crustaceans, such as shrimps, that make up part of its diet. Flying overhead in a V-formation, with their brilliant plumage standing out against the cool green landscape, scarlet ibises are an unforgettable sight in the wild.

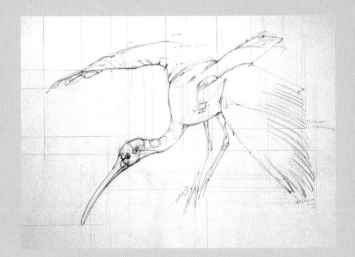

DRAWING
A very careful pencil drawing with feathers placed correctly is the first step.

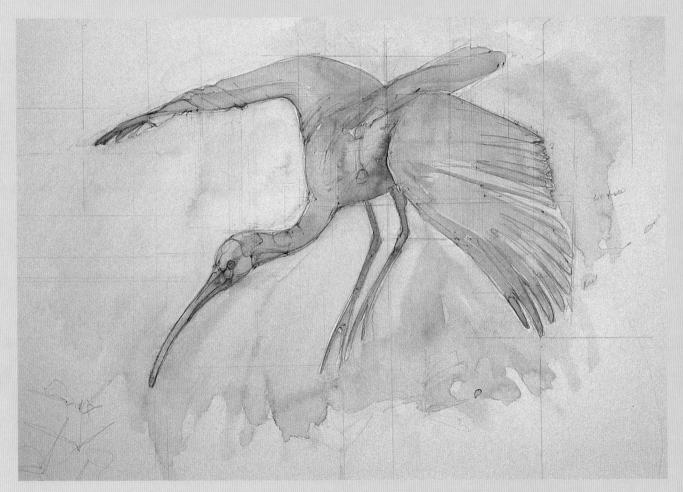

FIRST WASH, FIRST FEATHERS
Color does not have to be exact in the first wash, but keep it light. I've already introduced some cool colors in receding areas, and have laid a pale cool wash over the background. I use transparent colors at this stage, no cadmiums. I'm already distinguishing the flight feathers. I lay down the color, add water, then blot the brush and lift the puddle of water from the feather's center, leaving pigment on the margins.

ALTERNATING FORM AND TEXTURE

Apply each layer to a dry surface. Squint to find shadow areas to build form, then on the next layer refine texture; continue to alternate between the two.

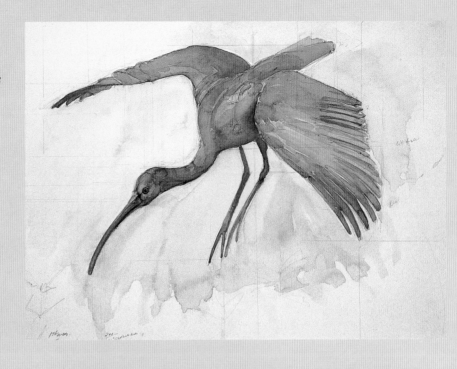

FINAL LAYERS

Apply the darkest darks in the final layers. Keep going back to the shadows for more specific information—shadows define form. Refine your edges, sharpening them in areas that come toward you.

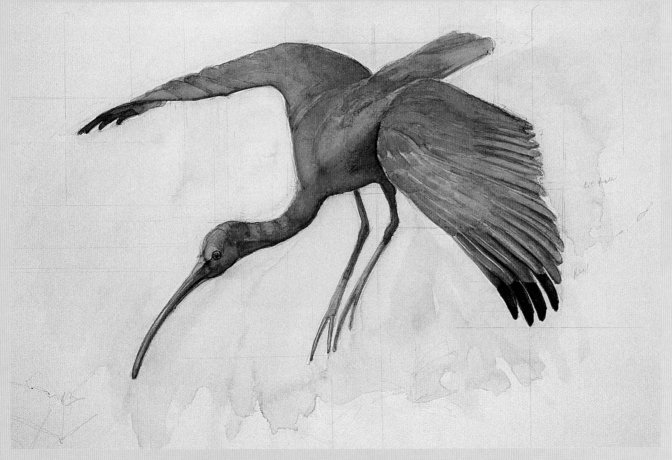

SCARLET IBIS
22 x 30 inches (56 x 76 cm). Collection of Katie and Bill O'Connor.

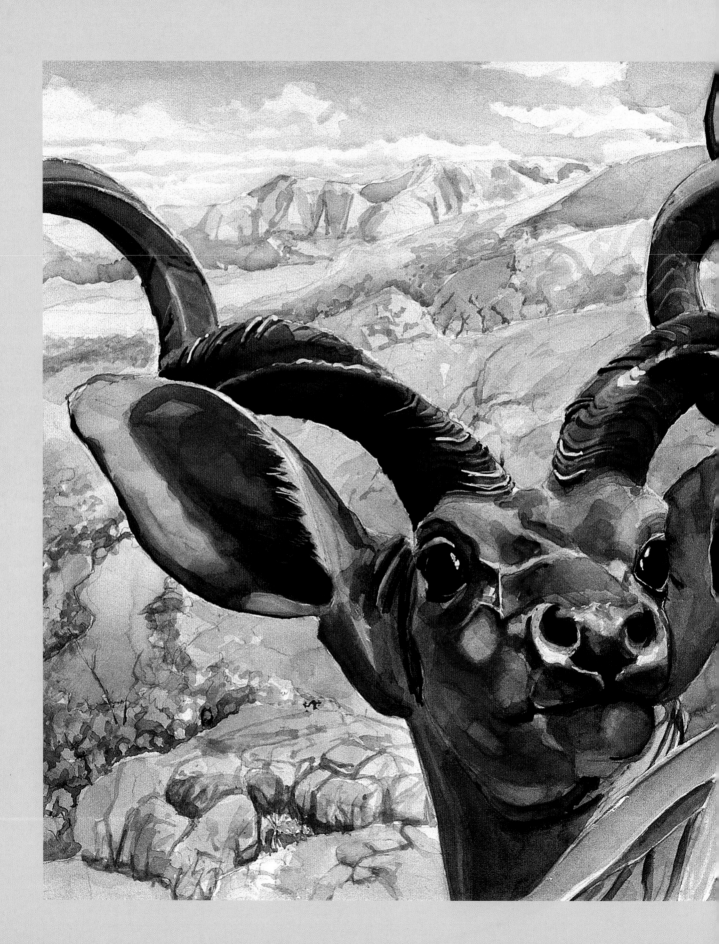

Portraiture

Faces in the animal kingdom are fascinating evidence of the unlimited creativity of nature. From the antelope's wide-set eyes to the anteater's magnificent snout, nearly every design has a function. There are endless combinations of characteristics, each imbued with personality.

Portraiture gives the artist the best chance to express an animal's enormous emotional range. No anthropomorphizing is involved when animals' eyes, lips, and ears tell their story. A wolf family's pride and tenderness with new cubs or a lioness's pleasure as she luxuriates in the sun become very apparent in an effective portrait. Our highly verbal culture discounts those who cannot speak, and it's our job as wildlife artists to make heard the animal language of expression and gesture.

GREATER KUDU
30 x 40 inches (76 x 102 cm). Collection of Patience Kramer.
The proud, alert head of the greater kudu clearly makes claim to his mountainous African habitat.

CAPTURING PERSONALITY

Your subject's personality separates the living being from the still-life subject. Your painting will show the subject's personality by three means: gesture, perspective, and expression, primarily of the eyes.

GESTURE

The gesture or pose of your subject conveys a great deal of information. Animals assume poses that communicate alertness, excitement, protectiveness, curiosity, or boredom. Before you begin to paint an animal, observe him closely. Decide what attitude best embodies this creature, and try to choose a pose that best reflects it.

PERSPECTIVE

An unusual perspective or unfamiliar view can greatly increase the impact of your piece. Most subjects are more arresting if you are looking up at them (low-angle view), or if they are at least at eye level. Looking down at an animal (high-angle view) usually creates a sense of remoteness. Animals that we usually see flying or living in trees are the exception to this rule.

Consider the feeling you're trying to impart when choosing the gesture and perspective—is the animal gentle, fierce, timid, noble, or tough? What do you think is going through his mind? Your response to your subject is more important than photographic draftsmanship.

EXPRESSION

Animals' faces are endlessly expressive, though often differently from ours. The cant of an ear, the flare of a nostril, or the tilt of a lip telegraphs messages to other animals, and to us if we look closely enough. However, to capture the viewer, the most important feature of an animal is his eyes.

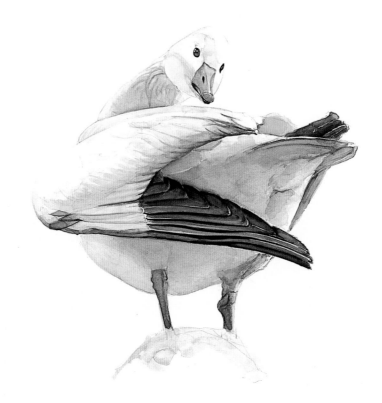

SNOW GOOSE
22 x 30 inches (56 x 76 cm)
The unusual low-angle perspective and preening gesture make for a striking portrait.

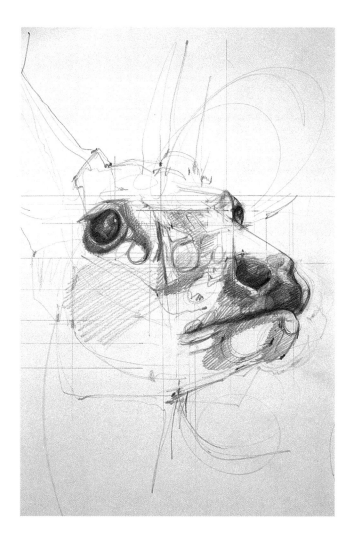

WHITE-TAILED DEER I

22 x 15 inches (56 x 38 cm)
*While this white-tailed deer's expression is
pleasant and gentle, it lacks impact*

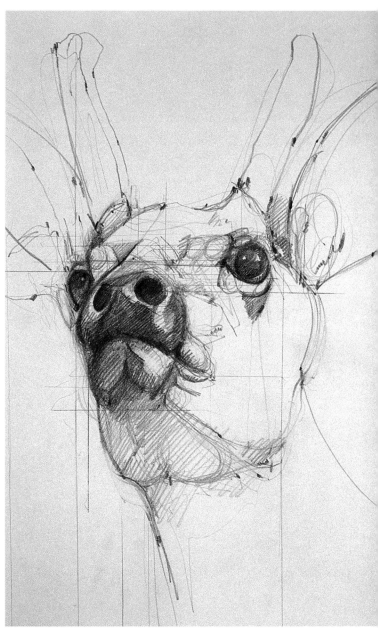

WHITE-TAILED DEER II

22 x 15 inches (56 x 38 cm)
*The same deer (from a mounted specimen) drawn
from a low-angle perspective looks considerably
more alert, intelligent, and generally interesting.*

IGUANA (DETAIL)
Original: 12 x 12 inches (30 x 30 cm).
Collection of Billy J. Macnamara.
We usually look at small animals, such as this iguana, from above,
but this "eye to eye" view is much more intimate and interesting.

AFRICAN ELEPHANT
40 x 40 inches (102 x 102 cm). Collection of Gary Deutsch.
The close, low-angle view of this massive animal gives a feeling of
excitement and impending danger.

Eyes

The eyes are windows to state of mind and intention, as well as to the soul. A friend of mine who is an amazing dog trainer takes his cues entirely from his dogs' eyes, ignoring all other body language. He has learned to distinguish eyes that are focused with enthusiasm, blurred with confusion, or hardened with the unblinking stare or upward gaze that precedes aggression.

Think in advance about the expression you want to invoke, and develop the eyes carefully. Paint with patience and attention to detail, and you will engage your viewer completely.

You literally look into an animal's eyes—they are translucent. In almost any animal, you see primarily iris and pupil—very little of the opaque "white of the eye" shows. You'll translate this luminous depth into paint by using many layers.

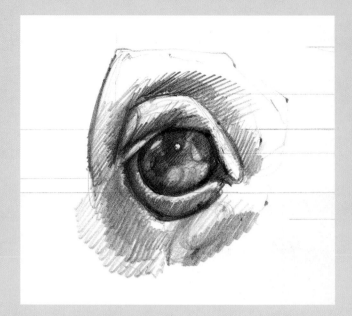

TONAL DRAWING

Start with a tonal study to determine values. I try to never fake the eyes, so I begin with a long slow look at my subject in good light. After the rough gesture drawing, I break the large shapes into smaller ones consisting of the pupil, iris, shadows, reflections, and the folds of the eyelids. Look at all the subtleties here. I would never paint over a drawing with this much graphite on it—this is for study purposes only. I then do a drawing that contains outlines only to form the base of my painting.

INITIAL WASHES

This is the initial light wash over a line drawing. The color doesn't have to be accurate at this point, but it's important to include both warm and cool colors.

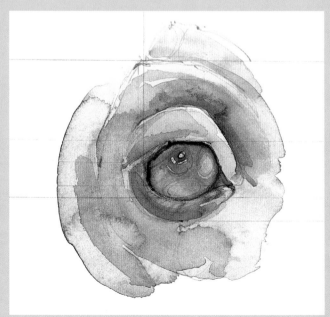

DEFINING FORM

Define form by washing in a variety of colors around the pupil. Assume the area under the lid to be in shadow, though often you won't be able to see it clearly. The lower half of the iris gathers light like a crystal goblet.

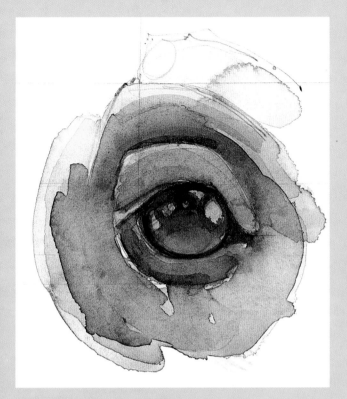

BRINGING IN DARKS

Avoiding the highlight areas, begin to lay in the dark of the pupil and let its color run into the adjacent colors. When these layers are dry begin to work in the final darks.

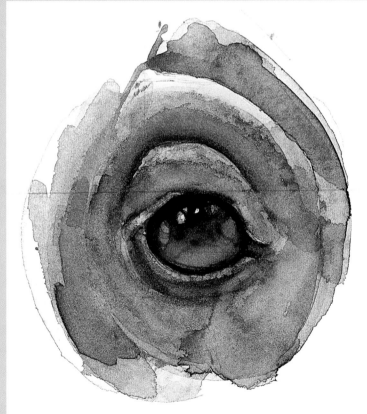

ACCENTS AND REFLECTIONS

The darkest area of the eye is where the brightest highlight overlaps the pupil. Never place that highlight in the very center of the eye (even if you see it there), or it will look like a cataract.

Paint the subtle secondary reflections darker than the highlights—this will make the eye come alive.

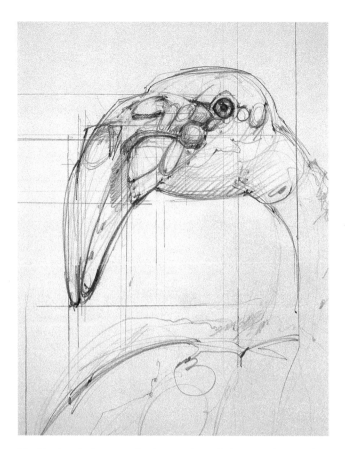

The flamingo's distinctive beak is very large (relative to the size of the head), with a distinctive curve. A careful drawing will ensure that you get the size and shape just right before laying down any paint.

BEAKS AND HORNS

The hard, shiny surfaces of beaks and horns contrast beautifully with the soft or bristly textures of fur and feathers. There is great variation in these features, from the massive and textured horns of a Cape buffalo to the the tiny and smoothly delicate horns on some beetles, from the powerful beak of a tortoise to a hummingbird's tiny nectar-sipper.

BEAKS

Unusually shaped beaks can seem difficult to draw, so remember to stick to the basics. Establish a home length, usually the eye, and measure to establish relationships, especially where the beak begins and ends. Draw your plumb-line grid.

The texture of a beak is slick and hard, so its surface is very reflective. If poor light makes the whole beak look solid black, for example, then think carefully and paint it as you know it must be, with the shadow color on the lower surfaces. In other words, make it look rounded, even if the light is poor and you can't see much dimension.

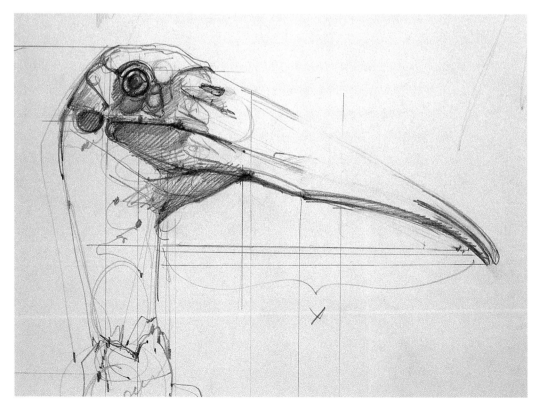

Use the empty spaces between elements of your drawing to judge relationships. For example, look at the triangle of negative space created by drawing a horizontal line on your paper from the tip of the stork's beak to the throat. Compare the triangle on your paper to the one you see by holding up your pencil to the subject—if your drawing's triangle is too narrow or too tall, you'll see that you need to adjust the drawing.

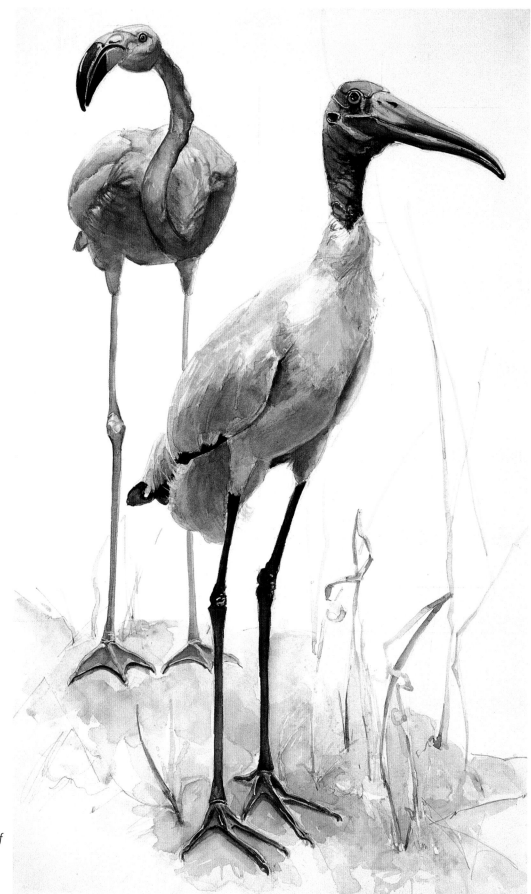

FLAMINGO AND STORK

40 x 30 inches
(102 x 76 cm).
Collection of Marilynn
and Julius Sparacino.
These birds are full of
character and personality.
The shiny dimensionality of
the beaks contrasts nicely
with the texture of the
feathers and the scaly legs.

Bald Eagle

The bald eagle is a fierce and impressive bird. White head flashes against blue sky in broad-winged flight; yellow eyes glare defiance up close. And yet I sensed a surprising vulnerability as I stood 10 feet (3 m) from a bald eagle in Puget Sound, expecting a strident scream of warning, only to hear a soft robin-like warble that sounded oddly like gentle concern. I try to bring just a hint of this softness into my painting.

PENCIL DRAWING

Measure carefully—it's a lot easier to change things in this stage than after you've begun to paint.

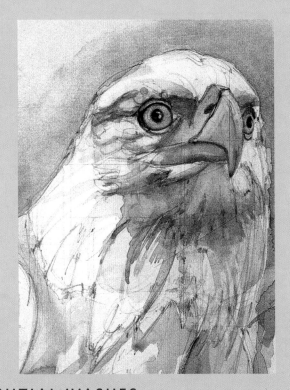

INITIAL WASHES

Be careful to preserve the white of the paper on the light side of the bird's head. Introduce plenty of pure color in shadow areas, but keep it light in tone. Keep the light side of the beak very light. Remember that you can always go darker and duller, but not the other way around. Begin light background washes.

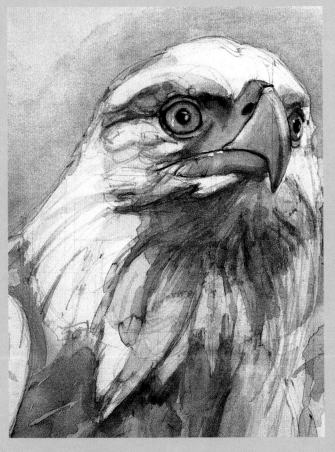

BUILDING STRONG DARKS, PRESERVING LIGHTS

Intensify shadow color and begin to build strong darks. Preserve your highlights, including the ones on the shadow side of the beak.

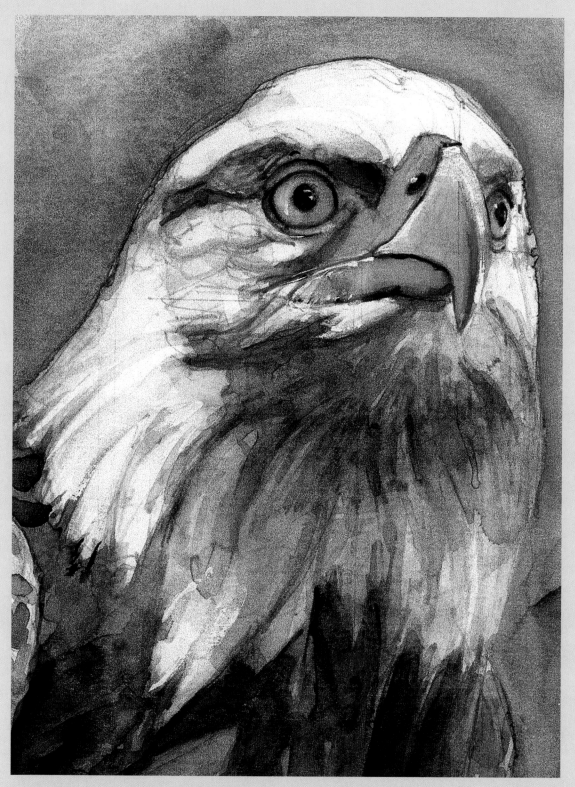

DARK AND LIGHT ACCENTS
*Finish with accents, dark and light. You can use gouache
for pure white accents or scrape the (absolutely dry)
finished painting with a No. 16 craft knife blade.*

BALD EAGLE
10 x 8 inches (25 x 20 cm). Collection of Todd Felix.

HORNS

Everything said about painting beaks also applies to painting horns. Let them shine by using high contrast. Leave pure whites for the brightest highlights. In a pinch you can apply highlights later with white gouache as I often do. Be sure to include plenty of color in the darkest areas. Show volume by using a full range of values, including reflected light (light reflecting from other surfaces back into shadow areas). It is especially important to pay careful attention to values when painting shiny surfaces such as horns.

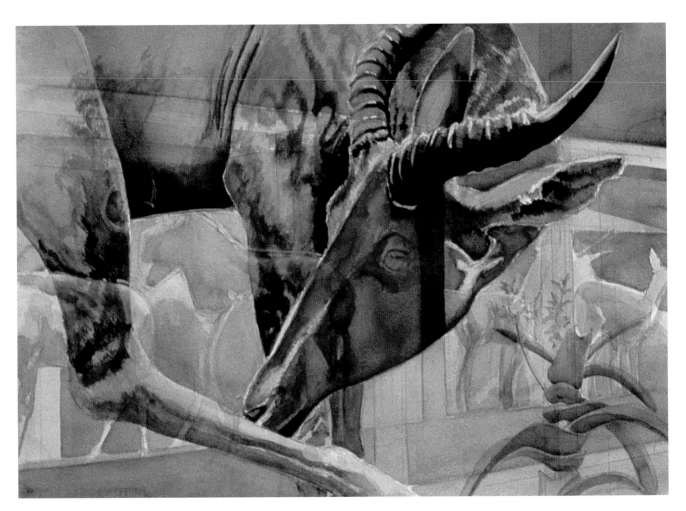

SASSABY

30 x 40 inches (76 x 102 cm). Collection of the Field Museum.
The sassaby's smoothly rippled horns show higher contrast than those of the Dall's sheep (right). To show high contrast, place the brightest highlight (I used white gouache here) crisply on top of a very dark area of the horn. Since I painted this in a dark museum hall, I included the very evident reflections of other displays as part of the design.

DALL'S SHEEP

60 x 40 inches (152 x 102 cm)
Male Dall's sheep use their heavy horns (attached to thick skulls!) for serious head-butting during mating season. The species is very much defined by its distinctive horns.

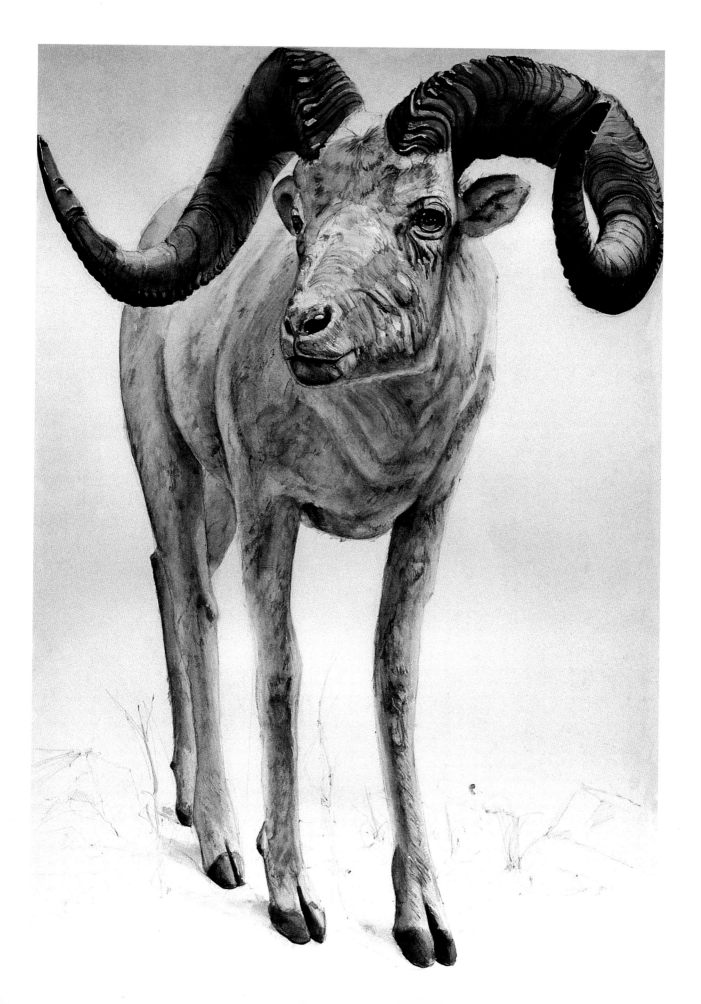

Habitat

An animal painted with no background can be very striking, and often I allow the simplicity of pure white paper to present my subject. But there are other times when I want some sort of landscape habitat or background to provide context and support.

Most of the great wildlife artists have included habitat in their paintings, and you might wonder at taking on a subject with such history. You might feel that there is nothing that hasn't been done. This is truly nonsense—if every fingerprint can be different, so can every approach to a common subject.

THREE IGUANAS
30 x 40 inches (76 x 102 cm)
The green iguana (top), Galápagos marine iguana (left), and rhinoceros iguana (right) illustrate the range from considerable to no camouflage. Since the marine lizard is, of course, from a different habitat, I wanted him to look out of place.

BUILDING FIGURE AND HABITAT

The animal-habitat relationship in a painting is a bit like a couple dancing—one or the other must lead. It's hard to make a painting work if the animal and the landscape have equal weight. Let one be the setting for the other. The animal usually dominates or leads in my paintings. You can make your own decision, but sustain it throughout the piece.

The most important thing I've learned about painting animals within a habitat setting is that all parts of the painting must be worked together. If you paint the subject first and then fill in the background around it, you'll probably end up with an artificial, patchwork look. Colors and tones all affect each other: a green background makes a red subject seem brighter, and a dark background makes any subject seem paler.

Often it's most effective to leave your habitat background in its early stages, light and suggestive. It creates a framework for your subject without becoming distracting. When painting an animal with a more finished background, again begin with a wash that includes both subject and habitat, and develop both together for a while. At a certain point you'll leave the background alone for the most part and focus on the animal so that she will dominate.

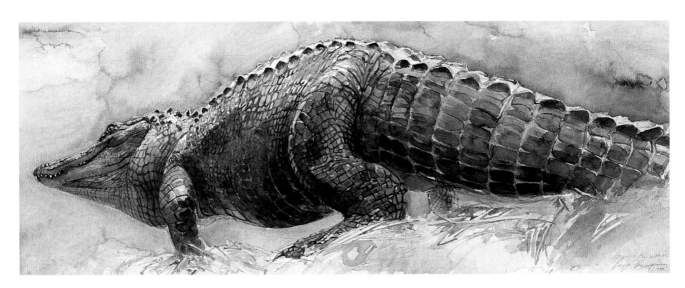

AMERICAN ALLIGATOR
22 x 50 inches (56 x 127 cm). Collection of the Field Museum.
The light wash around the alligator merely suggests habitat. It includes many of the colors of the animal. Because I kept it simple, the habitat does not attract attention away from my subject.

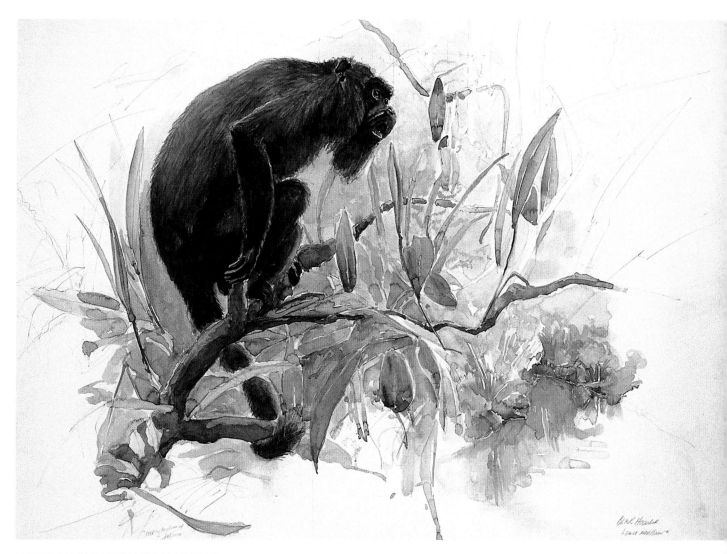

HOWLER MONKEY IN HABITAT

30 x 40 inches (76 x 102 cm)

While the monkey was painted from life, the habitat came from photographs that I had taken in Belize. I combined everything by working with both the actual monkey and the photographs in front of me.

I started with light washes of blue, red, and yellow. They covered the monkey as well as the background, and are still visible in many areas of the finished piece. Don't rely too much on out-of-the-tube greens, especially in the first washes. All of these leaves began with yellow and blue only. Subsequent layers of green and red supplied strong values and crisp edges to pull the correct areas forward. Notice the reds that mingle with and give life to the greens.

In the river scene in the painting's lower right corner, you can find many light spaces where the first washes show through.

LANDSCAPE

The more developed habitat painting is essentially a landscape, so let's talk about landscape separately for a moment. Your job is to create a feeling of depth and space, which you'll do with layers. Work from light to dark as always. As you apply more layers, be sure to leave "holes," snatches of your light first wash, between clumps of foliage to show sky and between leaves to indicate distant leaves. This technique will add depth and light to your landscape.

Gently bring your foreground into prominence with sharper edges and stronger contrasts. Using warmer and more intense colors in the foreground and cooler, duller colors in the background will also help to create the illusion of depth.

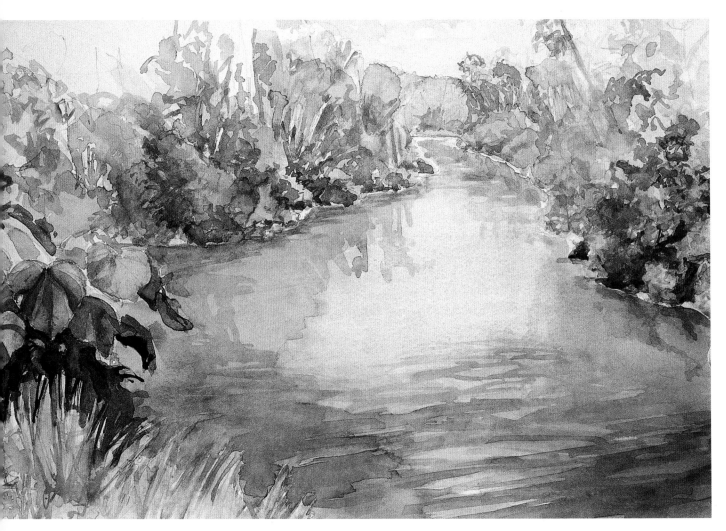

VIEW OF THE AMAZON (DETAIL)
Original: 14 x 30 inches (36 x 76 cm). Collection of Colleen Halleron.
This landscape is made up of many transparent layers. Lots of small spaces or holes have been left throughout the trees, grasses, and water. These spaces allow the sky to peek through, creating the illusion of space.

MADAGASCAR LANDSCAPE
22 x 30 inches (56 x 76 cm). Collection of Mrs. Robert Creevy.
*There's almost a fantasy quality to this landscape painting with
its floating hibiscus blossoms.*

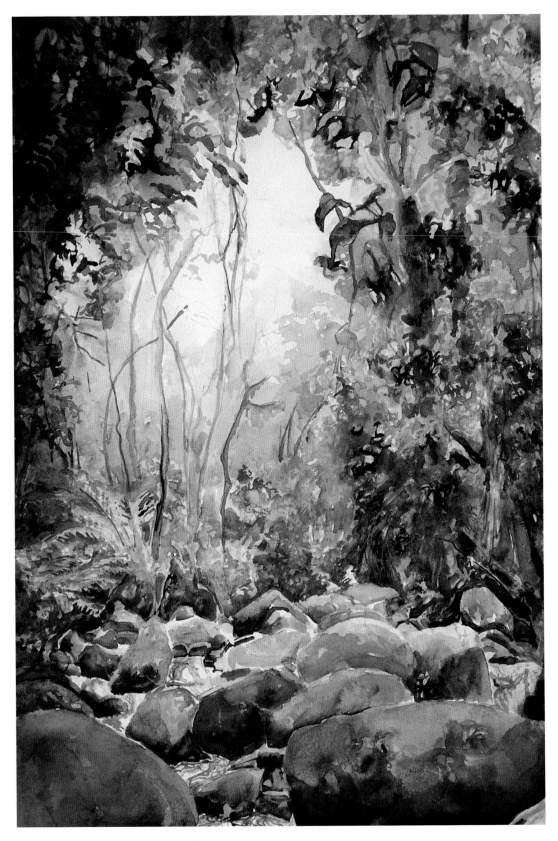

MADAGASCAR RAIN FOREST
40 x 22 inches (102 x 56 cm)
Take care not to use only standard, expected colors in your landscapes.
Notice all the reds, violets, and cool blues in this "green" jungle.

Great Blue Heron

The great blue heron exudes poise and patience, stand-ing single and still in wait of careless fish venturing within range. Snake-like neck arcs downward; deadly beak spears a large fish or seizes a small one. There's a long, slow swallow, a cranky *skrwaak,* and with steady, heavy wing beats, the heron launches.

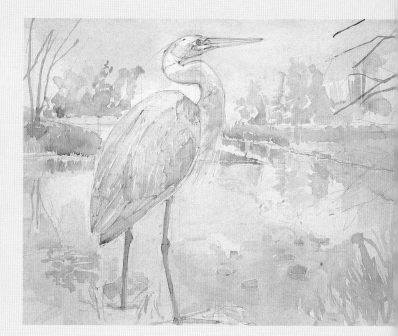

INITIAL WASHES

The first washes cover the entire page, subject and background. In this painting, the bird was painted from a museum specimen and the habitat from a series of field sketches and photos.

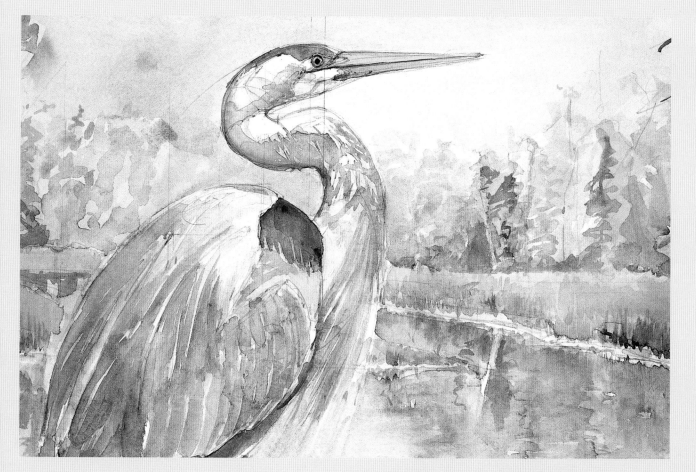

BUILDING COLOR HARMONY

Everything develops together. Keep your brush moving, applying each color in many places so that color harmony builds naturally.

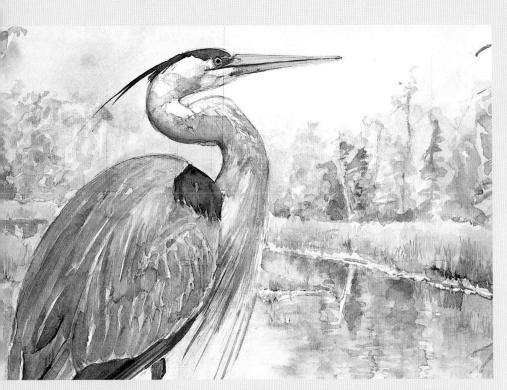

SHADOWS AND EDGES
Continue to strengthen shadows throughout, but from now on focus more on the subject and let the background fall back a bit. Leave edges soft in the background.

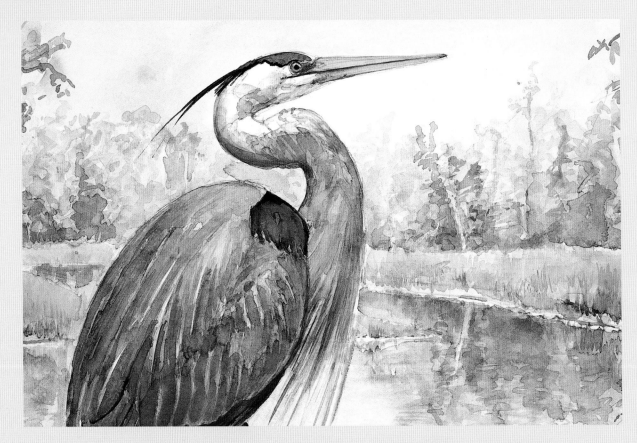

LIGHT AND DARK ACCENTS
Bring the heron forward with light and dark accents and sharp edges.

WORKING ALL AROUND

*Let your eye roam around the painting, making sure everything works
together. Sharpen your light and dark accents in the last stage.*

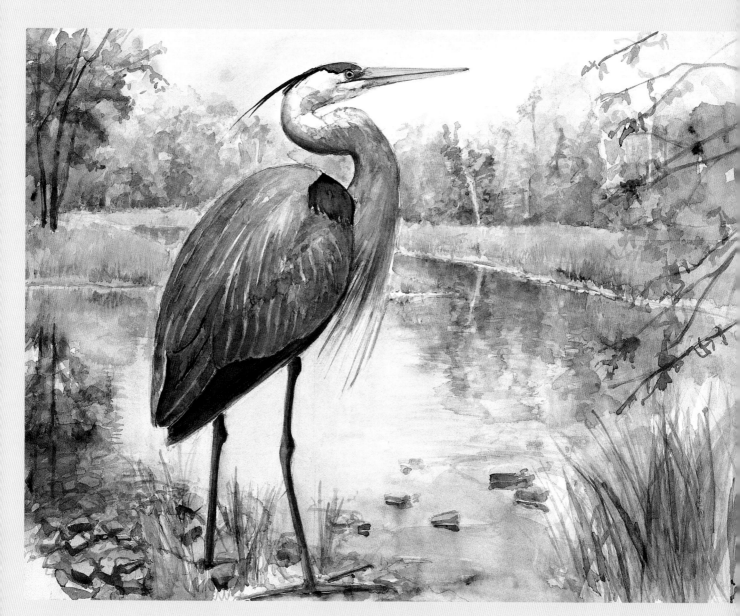

GREAT BLUE HERON IN HABITAT
22 x 30 inches (56 x 76 cm).
Collection of Jody and Matthew O'Connor.

AFTERWORD

Let us consider your mind for a minute, because it can be the single biggest problem when creating artwork. Rational thinking may say that you have to do "good" work, whatever that is, to justify the time you spend, and then you should show and sell your work for it to have value.

Get off that channel. See the worth in the process itself. You are participating in active meditation—think of it as exercise of the spirit. Your work and your spirit will grow together, regardless of other results.

Don't worry about the long and distinguished history of wildlife painting or obsess too much about creating something "new"—it's more noble and difficult to be ourselves. If we can approach our favorite subject without concern for what anyone will think, our uniqueness will develop naturally. Wildlife speaks to each of us directly, which means that all we have to do to interpret it is listen to our hearts.

You've been into my world—now be brave and paint!

ANTEATER
30 x 30 inches (76 x 76 cm)

ABOUT THE AUTHORS

PEGGY MACNAMARA

Author and artist Peggy Macnamara has been painting wildlife for over twenty years. She is the only artist-in-residence at the Field Museum in Chicago, and travels with expeditions of the Conservation and Zoology departments to paint on location. Peggy is also a professor at the Art Institute of Chicago, where she teaches and demonstrates her unique drawing and watercolor methods. She exhibits widely in galleries, as well as having work in the permanent collections of the Field Museum and the Illinois State Museum. She has a Master's degree in art history. Peggy has a husband and seven children and lives in Evanston, Illinois.

MARLENE HILL DONNELLY

Co-author Marlene Hill Donnelly is a writer and artist, with degrees in both art and zoology. She has been a staff illustrator for the Field Museum for over twenty years. She travels widely to write and to paint wildlife subjects and is a veteran scuba diver. Marlene also illustrates children's books, textbooks, and botanical books. She teaches classes and workshops at the Field Museum, the Art Institute of Chicago, and the Chicago Botanic Garden. Marlene lives in Glenview, Illinois, with her husband, Rett, and their four dogs.

INDEX